Turner

Noel Gregory

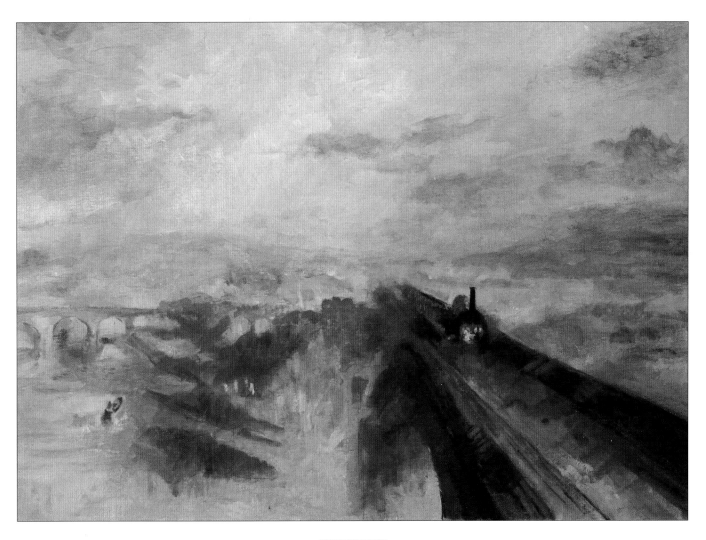

TRACING
1

SEARCH PRESS

First published in Great Britain 2010

Search Press Limited
Wellwood, North Farm Road,
Tunbridge Wells, Kent TN2 3DR

Text copyright © Noel Gregory 2010

Photographs by Debbie Patterson at Search Press Studios, except for pages 1, 2, 4–5 and 64, artist's own; page 7 © The Art Archive/Tate Gallery London/Eileen Tweedy

Photographs and design copyright © Search Press Ltd 2010

ISBN: 978-1-84448-579-6

The Publishers and author can accept no responsibility for any consequences arising from the information, advice or instructions given in this publication.

Readers are permitted to reproduce any of the tracings or paintings in this book for their personal use, or for the purposes of selling for charity, free of charge and without the prior permission of the Publishers. Any use of the tracings or paintings for commercial purposes is not permitted without the prior permission of the Publishers.

Suppliers
If you have any difficulty obtaining any of the materials and equipment mentioned in this book, please visit the Search Press website:
www.searchpress.com

Publisher's note
All the step-by-step photographs in this book feature the author, Noel Gregory, demonstrating his acrylic painting techniques. No models have been used.

Please note: when removing the perforated sheets of tracing paper from the book, first score them, then carefully pull out each sheet.

Printed in China

Dedication
I dedicate this book to all my art students in Bedar in Almeria, southern Spain.

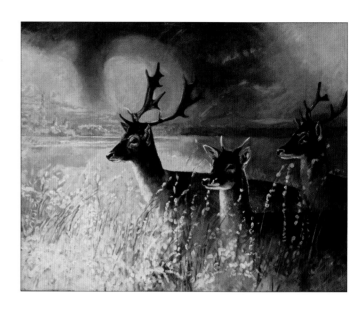

Acknowledgements
Thanks to my main man Martin de la Bédoyère for all his help and encouragement, and my editor, Edd. If you find any mistakes – please blame him!

Contents

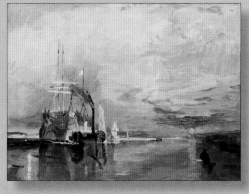

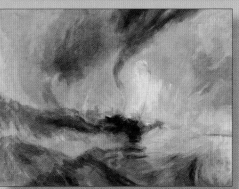

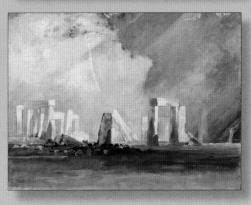

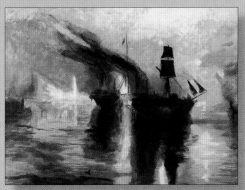

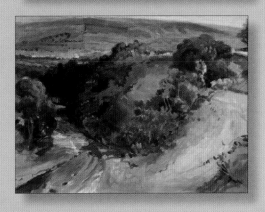

Introduction

The choice of just six images for this book has not been an easy one for me because of the thousands of works the master left us, and because his paintings tended to be either on a huge scale, or very detailed, or both. This renders some too difficult to scale down to the format required. Another important fact is that, being the father of abstract painting, Turner's work is often too loose to copy on such a small scale. However the master has so many iconic paintings that it would be impossible to miss out images like *The Fighting Temeraire* or *Snowstorm*, so they were a natural inclusion, even if not the easiest to copy!

Turner's images were either watercolours or oil paintings, so to reproduce them in acrylics – which were not even thought about in the artist's time – may seem an unusual choice of medium. However I am convinced that he would have loved the challenge of such an art range and would have used it to great effect.

When searching for source material on the original paintings on the internet and in art books, I was staggered by the difference in hue and tone between them. In some cases, they are so different that you can wonder if you are seeing the same painting. I recommend choosing the source you like best, and using that as reference. The other option is to simply 'borrow' the original from the National Gallery and take it home to your studio – and good luck with that plan!

> **Publisher's note**
> In addition to the five projects in the book, a bonus tracing is provided for the painting on page 1, so that you can have a go once you feel confident with the techniques and use of colour shown in the other projects. You can find the tracing at the start of the pull-out section.

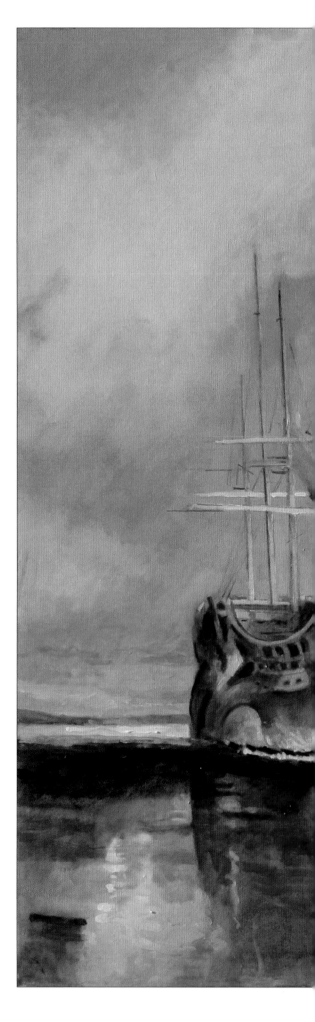

The Fighting Temeraire
101 x 76cm (40 x 30in)

Scale will always be a problem with any reinterpretation of another artist's work because it is often the scale that gives the work such power.

Because I enjoyed painting the picture so much, I used a photocopier to enlarge the tracing, then painted it again at this larger size. You can enlarge the tracing on a photocopier in order to scale up the image.

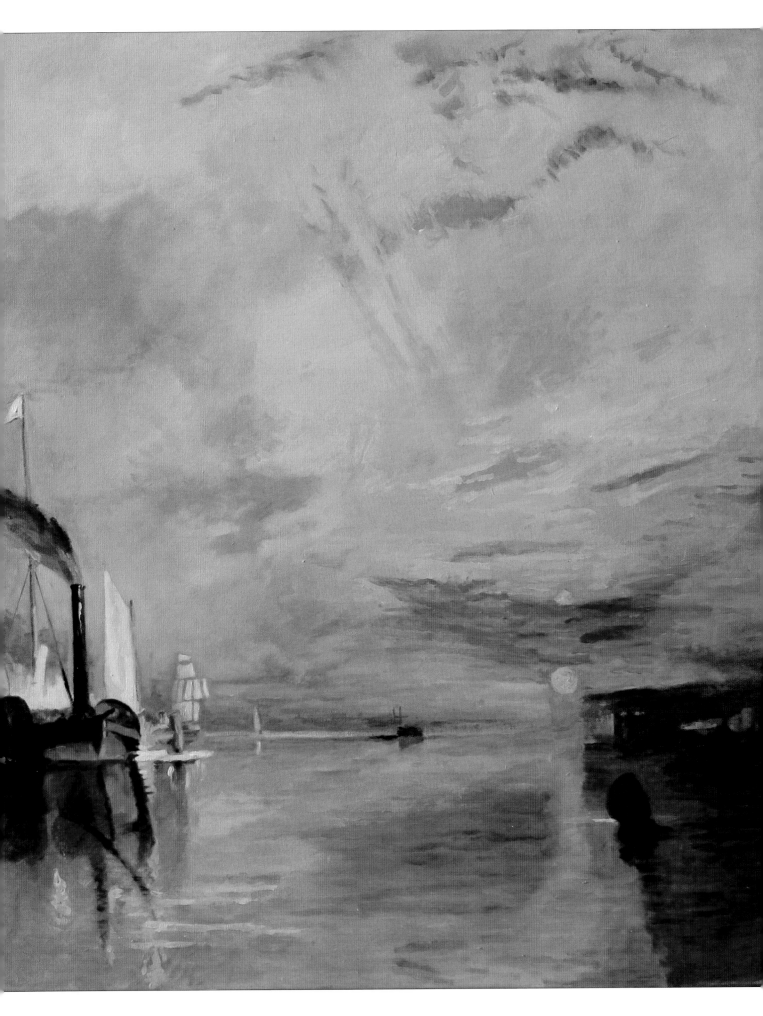

J. M. W. Turner

Reckoned by many to be the greatest British painter, Joseph Mallord William Turner was born on 23 April, 1775, in Covent Garden. He is commonly referred to as the 'painter of light' and his use of thin washes gave his pictures a great sense of tone and colour. He was not only a master of the use of oil pigments but also an innovator in watercolour, using it in his thousands of sketches as a starting point for so many of his famous canvases.

Turner most loved the study of the natural world which prompted the art critic John Ruskin to describe him as the artist who could most 'stirringly and truthfully measure the moods of nature'. He would watercolour for hours, making sketches of natural phenomena such as rain, sunlight, shadows and of course storms, especially at sea. He was also the greatest master of the sky – especially sunsets, which set the mood for so many of his marine subjects.

He studied drawing and painting at the Royal Academy School from the age of fourteen, exhibiting a watercolour at the summer exhibition after a year at the Academy. His first oil was accepted six years later in 1796 with the painting entitled *Fishermen at Sea*. This was to be the start of a very successful career.

He travelled extensively, firstly throughout Britain and then, in 1802, to the Netherlands, Switzerland, Germany, Italy, and particularly France and Venice, which most agree inspired his greatest work. This same year he was made a full member of the Royal Academy, the youngest ever recorded, and five years later, he was offered the post of Professor of Perspective. He remained involved with the Academy throughout his life, becoming President in 1845.

His work was often completely abstract in conception, for Turner translated what he saw into tone-filled impressions with Romantic ideology. It is for this reason that he has been called the father of Impressionism. This approach incurred the displeasure of the classical artists but was to influence many of the Romantic and picturesque schools, and his techniques were greatly studied by many artists of the day. His subjects – idyllic castles, abbeys and landscapes – are often compared with his those of contemporary John Constable, but unlike Constable, Turner's were not so traditional in concept and he was far more experimental in his technique.

His later work for the Academy showed how his work had progressed to a stage that his canvases would often be submitted unfinished and be completed only during the varnishing days, a time when other artists were involved only with the last moments of protecting their work.

Turner was very commercial in his attitude towards his paintings. He understood the importance of print-making and produced limited editions of his images. Involving himself with engravers and publishers, he produced his *Liber Studiorum* annually for twelve years, which showed his watercolours from his travels.

His original oils and watercolours were sold to wealthy patrons and much of this success was owed to the support from the greatest art critic of the times, John Ruskin, whose book *Modern Painters* was largely concerned with a defence of the work of Turner.

Later in life, and even with his great following, Turner became an eccentric without close friends. The sole exception was his father, with whom he lived for thirty years. He refused to see anyone or to let anybody see him paint, never wanting to sell his paintings and getting depressed when he did sell one. In 1851 he disappeared and several months later was found extremely ill in a house in Chelsea by his partner and mother of his two daughters, Sarah Booth. He died the next day on December 19th, and his last words were said to be 'The sun is God'.

He left a considerable fortune and a legacy of thousands of work of art for all to enjoy for centuries. He was buried in St Paul's Cathedral, lying next to Sir Joshua Reynolds at his own request.

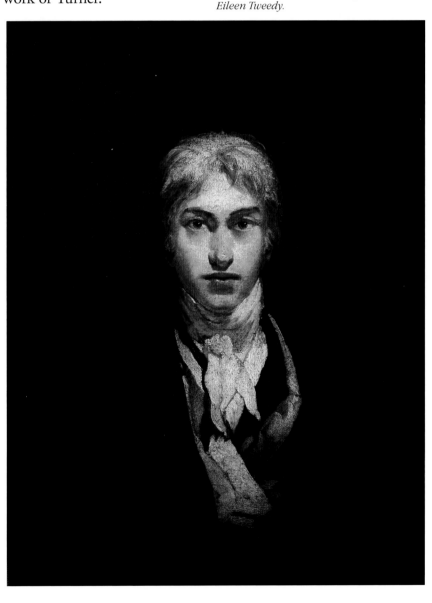

Self-portrait of J. M. W. Turner
58 x 74cm (23 x 29in)

A representation of the artist in the year he was elected to the Royal Academy, oil on canvas, c.1799.

© *The Art Archive/Tate Gallery London/ Eileen Tweedy.*

Materials

Paints

Turner was both extremely secretive and very experimental with his working methods and materials, which is part of what makes his works so creative and beautiful. He used both oils and watercolours for his painting. For the projects in this book we will use acrylic paints, which are simple to use. These were not available to Turner, but I am confident that he would have relished the opportunity to use them.

I use the following acrylic paints in this book, and they are a good palette for general use: cerulean blue, ultramarine blue, burnt umber, burnt sienna, dioxazine purple, permanent alizarin crimson, cadmium red medium, cadmium orange, transparent yellow, titanium white, yellow ochre and Hooker's green.

You might like to use cadmium yellow medium in place of transparent yellow, as the former has better coverage.

Acrylic paints in tubes.

Surfaces

Any canvas or acrylic board may be used, but I have used canvas boards for the paintings in this book. These are rigid hardboard with canvas attached. If you can not get the exact size that the book requires, any larger one will suffice: simply transfer the tracing in the centre and leave a border round the outside. You can then trim the board to size if you wish.

A variety of canvases and canvas boards.

Brushes

I have deliberately limited my selection to four brushes for these projects, mainly because it is not necessary to have hundreds of different brushes. It is certainly necessary to have a selection of sizes, but rigid 'rules' about which sort of brush to use may be safely ignored if you have a favourite size or type with which you are comfortable.

The following are the brushes I used in this book: a large 7/8 mop brush for initial washes (although any other large soft brush is perfectly acceptable). I have also chosen a size 10 filbert and a size 2 flat for general painting as they are my particular favourites. The size 1 sable round was selected because it is a good drawing brush for detail.

From top: size 1 round, size 2 flat, size 10 filbert, 7/8 mop.

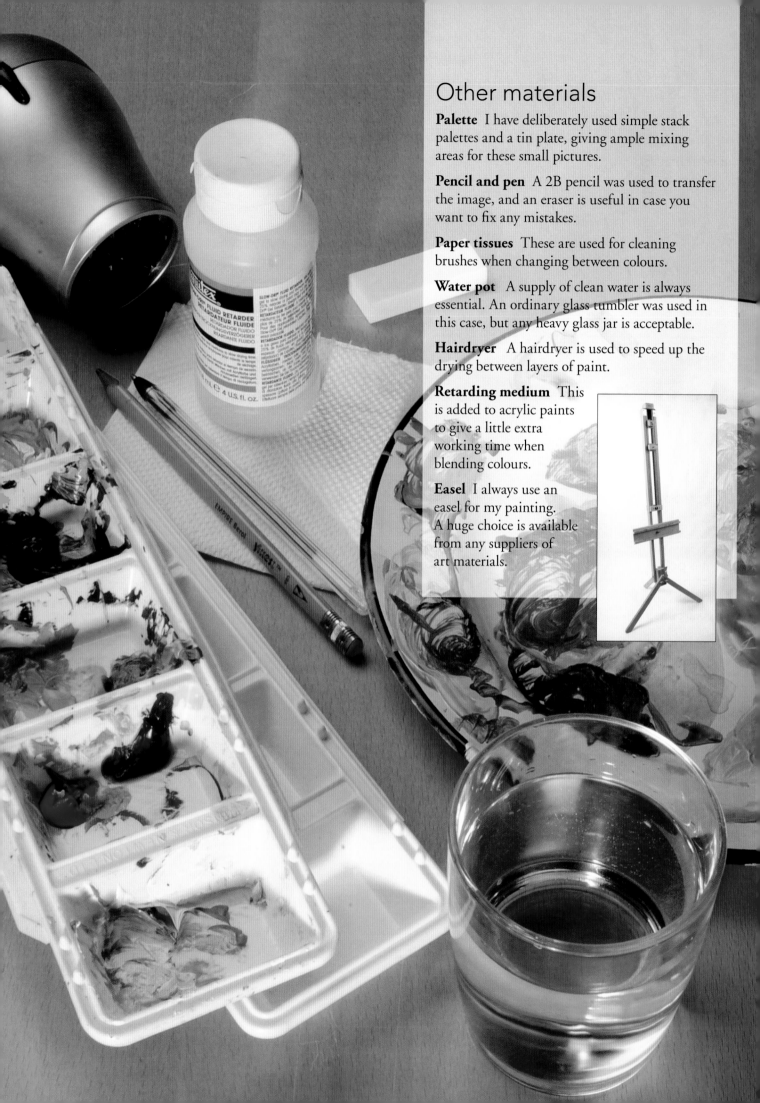

Other materials

Palette I have deliberately used simple stack palettes and a tin plate, giving ample mixing areas for these small pictures.

Pencil and pen A 2B pencil was used to transfer the image, and an eraser is useful in case you want to fix any mistakes.

Paper tissues These are used for cleaning brushes when changing between colours.

Water pot A supply of clean water is always essential. An ordinary glass tumbler was used in this case, but any heavy glass jar is acceptable.

Hairdryer A hairdryer is used to speed up the drying between layers of paint.

Retarding medium This is added to acrylic paints to give a little extra working time when blending colours.

Easel I always use an easel for my painting. A huge choice is available from any suppliers of art materials.

Transferring the image

It could not be easier to pull out a tracing from the front of this book and transfer the image on to canvas board. You should be able to reuse each tracing several times if you want to create different versions of the scene.

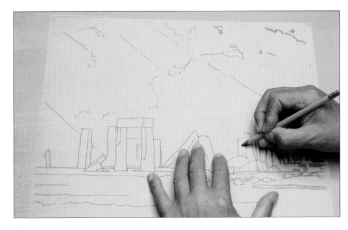

1 Scribble on the reverse of the tracing with a 2B pencil.

Tip

It is possible to use a suitably sized sheet of carbon paper to eliminate this step. Simply place it between the tracing and your canvas, and use a sharpened pencil to transfer the image.

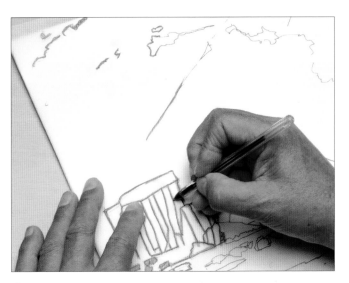

2 Turn the tracing right side up and place it face up on your board using masking tape. Use a pencil to go over all the lines of the tracing. If you are right-handed, work from left to right so as not to smudge what you have already drawn, and vice versa if you are left-handed.

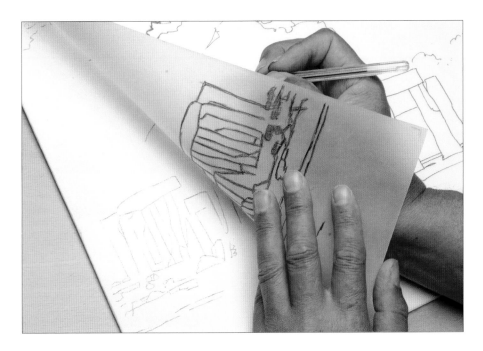

3 Lift up the tracing and you will see the drawing beginning to appear on the canvas board. Do not worry if it looks faint; if it is too strong, the graphite can smudge during the painting process and look untidy. Once the pencil marks are transferred, remove the tracing. You are now ready to paint!

The Fighting Temeraire

This painting symbolises the passing of the age of sail, depicting a forty-year-old veteran of the battle of Trafalgar being towed to her end by a steam engine.

Turner made his initial watercolour sketch of this painting while on a Margate steamer in September 1838, while the great ship was being towed to Rotherhithe to be broken at Beaton's shipyard. We know that what he saw and what he painted were very different: the ship had been stripped of her mast, sails and guns, and was being towed by two tugs. The painter also added the sunset, and it is now one of the best-known of his works. It is regarded as amongst Turner's finest works, and he always referred to it as 'my darling'.

You will need

Canvas board 56 x 38cm (22 x 15in)

Colours: cerulean blue, ultramarine blue, burnt umber, burnt sienna, dioxazine purple, permanent alizarin crimson, cadmium red medium, cadmium orange, transparent yellow, yellow ochre, titanium white, Hooker's green

Brushes: 7/8 mop, size 10 filbert, size 2 flat, size 1 round

Pencil and masking tape

1 Transfer the image following the instructions on page 11.

2 Lay in a very thin wash of cadmium orange over the whole canvas, using a size 7/8 mop brush. This takes away the white of the canvas.

3 Switch to a size 2 flat and use pure titanium white to block in the light areas; both the details on the lower left and the sky on the upper left.

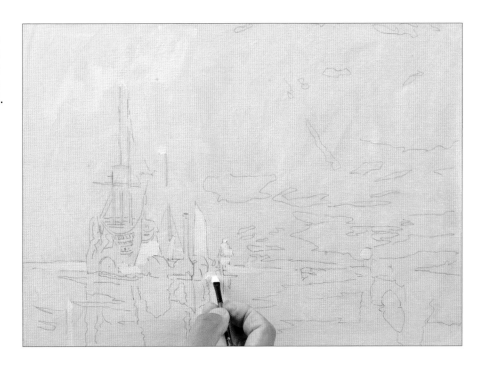

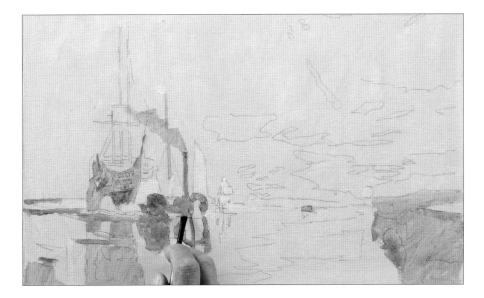

4 Use dilute burnt umber to block in the darkest areas of the painting as shown. Think of the paint as a watercolour to get the correct consistency.

Tip

Do not worry about the specific colours at this point – the important thing to get right is the contrast between the light and dark tones.

5 Make a dilute mix of cadmium red medium and use a size 10 filbert to lay in a wash over the clouds and reflections; then touch in the other red areas of the painting, still using very dilute paint.

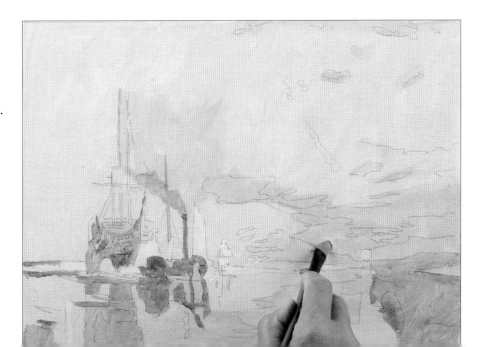

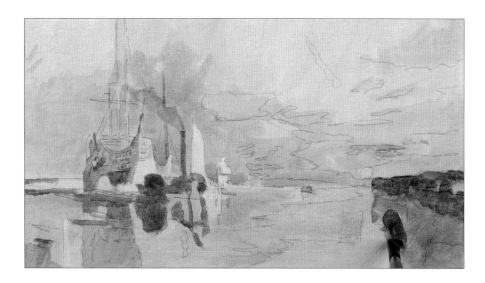

6 Add a touch of permanent alizarin crimson to ultramarine blue and dilute the mix. Still using the same brush, lay in an undercolour to the blue areas. Use a slightly stronger mix of the same colours to develop the rocky areas on the lower right.

7 With the undercolours laid in, we will now start using thicker paint for more controlled work. Switch to the size 2 flat and use the thicker blue and crimson mix to begin to develop darker areas, starting with the tug and its reflections.

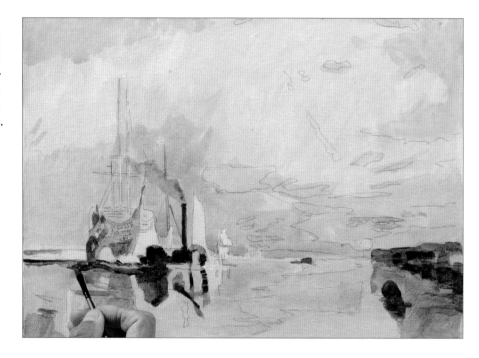

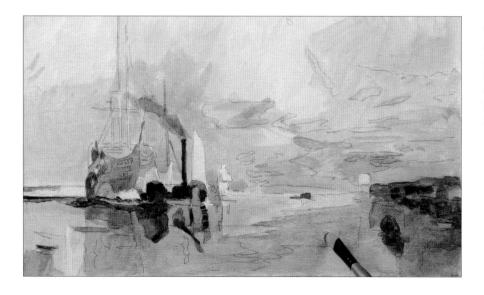

8 Using the size 10 filbert, make a slightly diluted mix of permanent alizarin crimson, cadmium red medium and cadmium orange for the redder areas; then add more cadmium orange to vary the hot areas.

9 Switch to pure ultramarine blue and the size 2 flat, to begin to develop the sky around the horizon and other bluer areas.

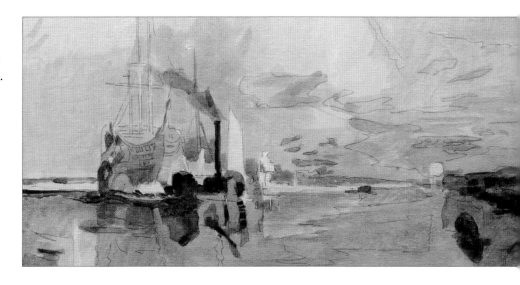

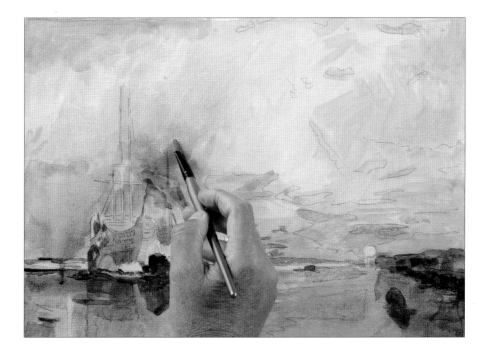

10 Change to the size 10 filbert and further develop the blues, working up into the sky and around the centre of the picture.

11 Use very dilute cadmium red medium to glaze the redder areas around the sun and the centre of the painting. Work outwards, further developing the reds on the painting; then switch to cadmium orange and repeat the process.

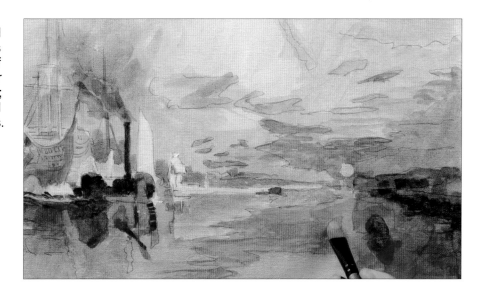

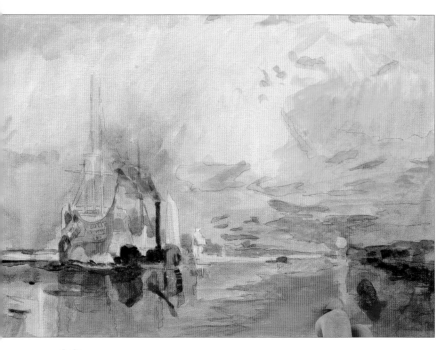

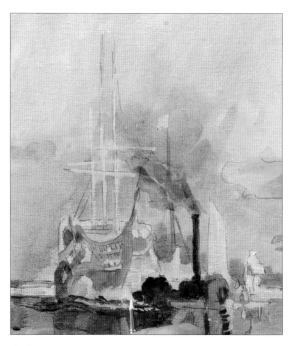

12 Still using the size 10 filbert, dilute the cadmium orange further and glaze the sky and sea as shown.

13 Make a thick mix of titanium white with touches of cadmium orange and cadmium red medium. Switch to the size 1 round and begin to draw in highlights, obscuring the pencil lines as shown. Start to detail the *Temeraire* itself at this point, drawing in the sails and light details.

14 Switch to the size 10 filbert and use the same thick mix with loose brushstrokes to break up and begin to obscure the bold pencil lines of the tracing.

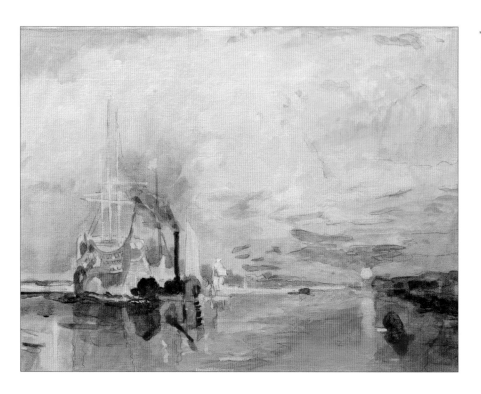

15 Mix burnt umber with a little ultramarine blue, titanium white and cadmium red medium, and use the size 1 round to draw in the detail on the *Temeraire* and across the painting. Add more ultramarine to the mix for the darker areas.

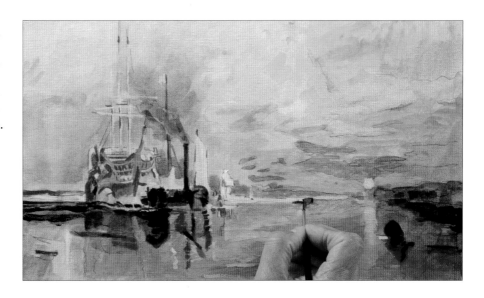

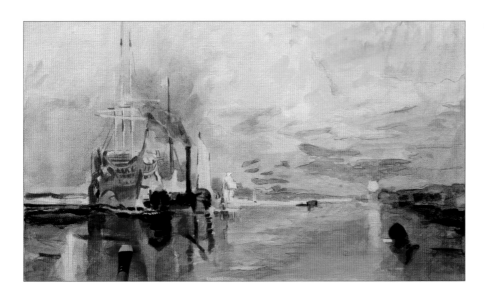

16 Allow the painting to dry thoroughly. Mix burnt umber with yellow ochre, dilute to a glaze, then use the size 10 filbert to overlay the painting as shown.

17 Switch to the size 2 flat and use a fairly dry mix of pure cadmium red to develop the cloud around the sun. Add a great deal of titanium white and add pinky touches to the clouds in the rest of the painting.

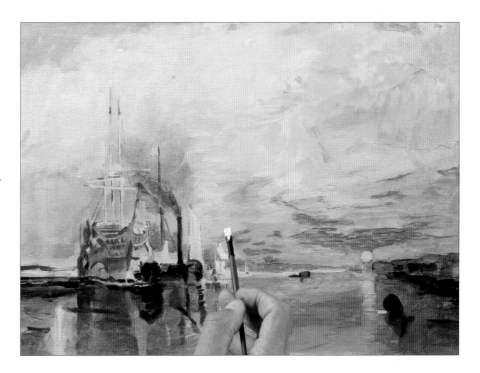

18 Still with the size 2 flat, add yellow touches around the right-hand side with nearly dry transparent yellow. Note how the dry mix brings out the texture of the canvas. Add titanium white to the mix and vary the hue in the same areas.

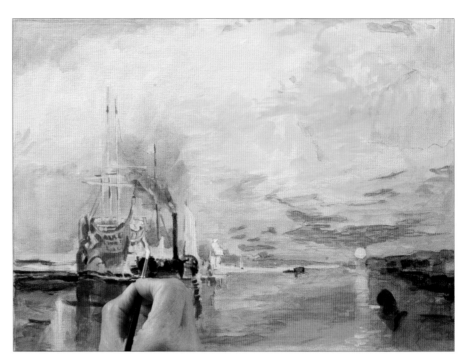

19 Switch to the size 1 round for small details across the painting, paying particular attention to the *Temeraire* herself. Use the colours already on your palette, refreshing them with new paint following the mixes noted earlier. Aim to balance the tones within the main shapes.

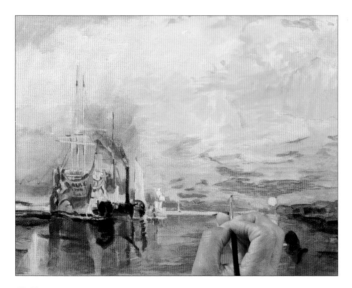

20 Make a rich grey mix with ultramarine blue, permanent alizarin crimson and titanium white, and reintroduce the darker neutral tones to the painting, blending them out with the clean size 10 filbert. Add a little titanium white to the mix to lift the colour nearer the sun.

21 Switch to the size 10 filbert. Mix titanium white, cadmium red medium and ultramarine blue, and feather it on around the sun as an almost dry mix with very light strokes, blending the colours in this part of the sky together.

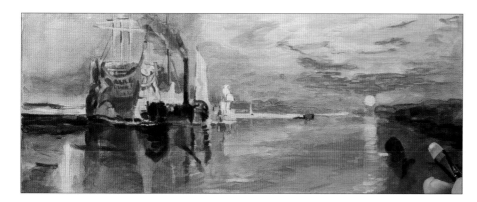

22 Mix transparent yellow, ultramarine blue and dioxazine purple together. Dilute the mix and glaze the far left and right of the sea and shaded side of the *Fighting Temeraire* herself.

23 Mix ultramarine blue, Hooker's green and dioxazine purple to create a very dark mix, and use this with the size 1 round to tighten the drawing and develop the details of the painting. Mix ultramarine blue with titanium white to cut in the sky around the rigging and masts with the size 10 filbert.

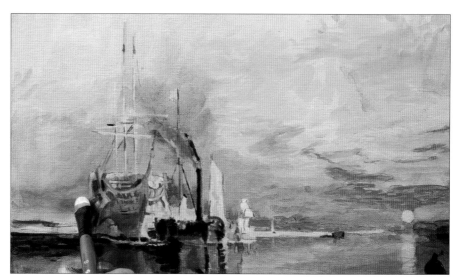

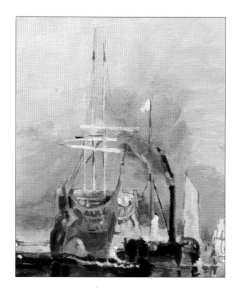

24 Use pure titanium white with the size 1 round to bring in very thick white highlights on the *Fighting Temeraire*.

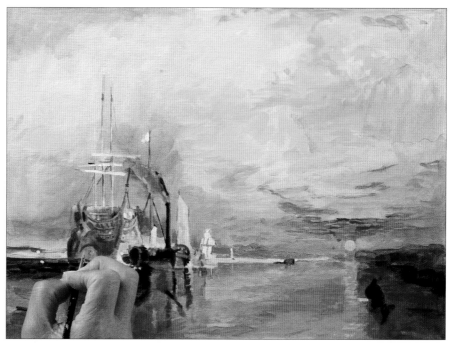

25 Complete the painting with some final touches of pure titanium white and a mix of cadmium red medium and the dark mix.

Overleaf

The finished painting.

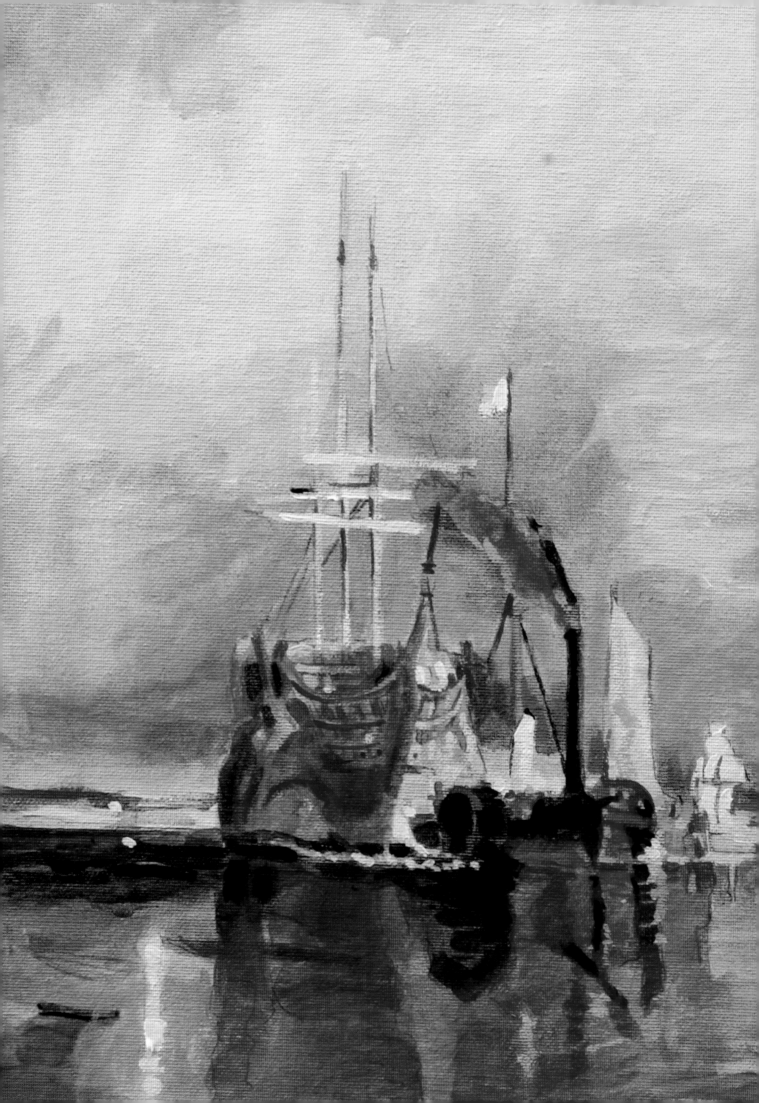

Snowstorm

Turner was said to have lashed himself for four hours to the mast of a small sailing ship in order to experience the power and force of a snowstorm at sea. This tells us precisely how long he would spend on painting this canvas of 91 x 122cm (36 x 48in), now in the National Gallery. The feeling of total involvement in the subject with *Snowstorm* is obvious and it makes you feel that nothing less than those hours of torture on the mast would ever produce such a splendid image. How he kept his paints from freezing and becoming unworkable will remain a mystery.

Turner was extremely secretive on how he produced his paintings and apart from doing extensive finishing work to them on the Royal Academy's varnishing days (when works were hung and artists could make small changes *in situ*) he took great pains to hide his techniques – so no step-by-step painting book by him then!

You will need

Canvas board 56 x 38cm (22 x 15in)

Colours: ultramarine blue, permanent alizarin crimson, titanium white, raw sienna, Hooker's green, cadmium orange, dioxazine purple, burnt sienna, cadmium red medium

Brushes: 7/8 mop brush, size 10 filbert, size 2 flat, size 1 round

Retarding medium

Masking tape

1 Transfer the image, following the instructions on page 11.

2 Create a very dilute mix of ultramarine blue and permanent alizarin crimson, and lay it in as a wash over the whole painting with the size 7/8 mop brush.

3 Allow the painting to dry a little, then apply pure titanium white to start the main areas of tonal structure. Apply the paint thickly with titanium white and the size 10 filbert.

4 Mix raw sienna with a little titanium white and dilute. Apply it as a wash to the dark areas, still using the size 10 filbert.

23

5 Add a little Hooker's green to make a dull green-brown, keeping the mix dilute and scrubbing it into the canvas very roughly. Blend the colour over the other areas near the centre to create a varied natural effect.

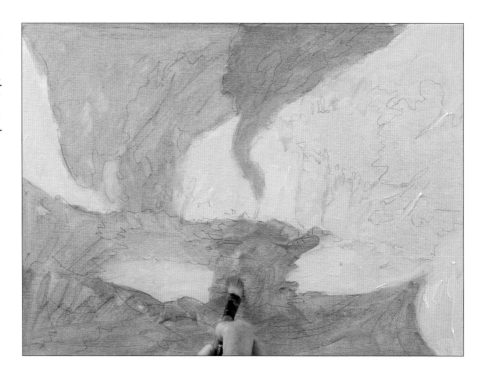

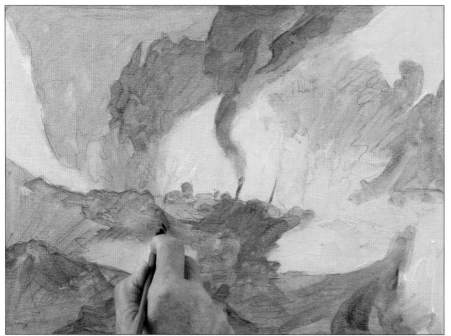

6 Add ultramarine blue to the mix for a deeper grey mix and lay in the suggestion of the darker areas. Do not worry about covering the lines as your paint should still be very dilute.

7 Add a lot of ultramarine blue and more titanium white to the mix to create a buttery mix, and begin to develop the centre of the painting with this thicker mix.

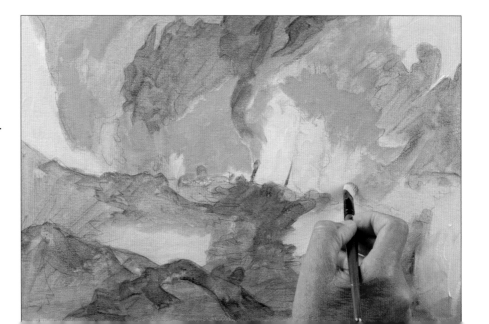

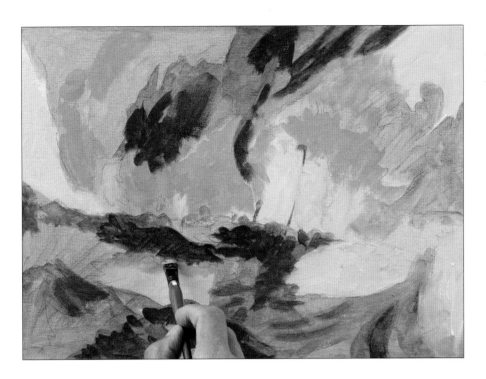

8 Mix ultramarine blue, Hooker's green and permanent alizarin crimson and block in the darker-toned areas.

9 Continue to feather in light strokes of this mix, still working fairly roughly.

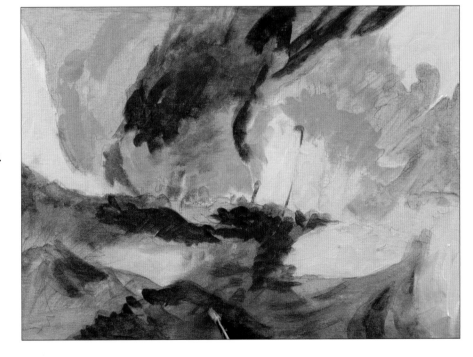

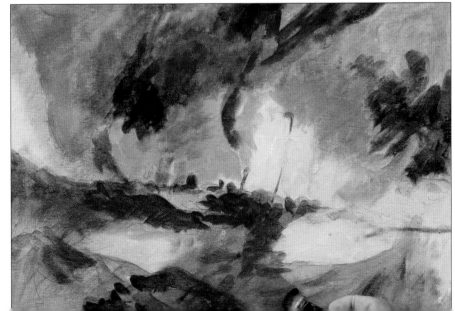

10 Add ultramarine blue to the mix and dilute slightly, then use this new mix to develop further darker areas. Allow the paint on the brush to dry slightly and scrub it in to blend the colours between the different areas. This helps to give the misty look.

11 Add a touch of ultramarine blue to cadmium orange then add a little retarding medium. Glaze this over the darker areas to warm them a little.

12 Add more ultramarine blue to the mix and re-glaze the areas at the upper left, lower left and lower right edges of the painting. Add more ultramarine blue and retarding medium to the mix and glaze the dark area on the right. Draw the fluid mix towards the centre a little.

13 Make a thick, dark mix of ultramarine blue, permanent alizarin crimson and Hooker's green, and use a size 2 flat to introduce the darkest areas in the centre and lower left. Use your finger to blend them into the canvas and hide any brushmarks.

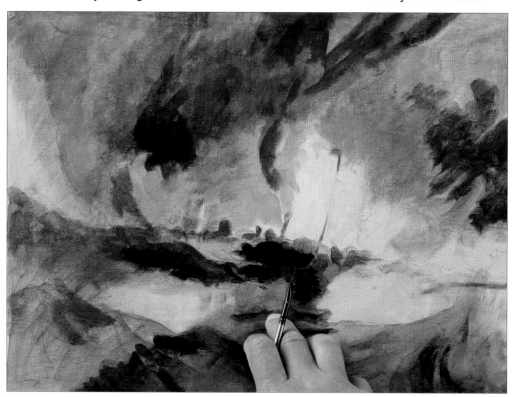

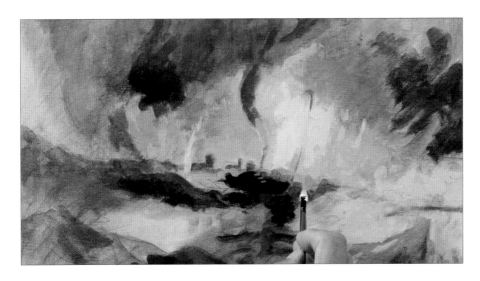

14 Add tiny touches of cadmium orange and ultramarine blue to titanium white and use the size 2 flat to add thickness and body to the lighter areas, varying the proportions of the colours slightly across the canvas to produce a varied flurry-like effect.

15 Add dioxazine purple to the dark mix (ultramarine blue, permanent alizarin crimson and Hooker's green), then thicken and tint it with titanium white. Use varying proportions of this mix across the painting with small, light strokes of the size 10 filbert in order to build up texture on the middle right, centre and lower right.

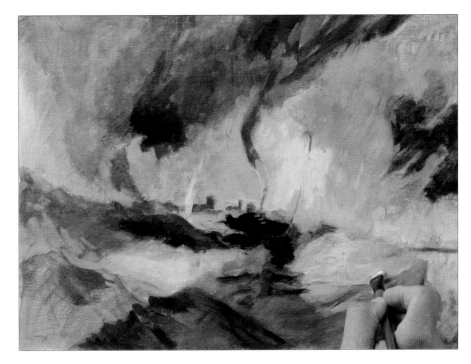

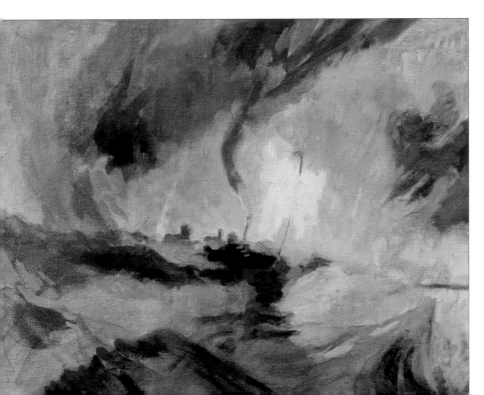

16 Use the size 10 filbert to apply light touches and strokes of a blue-grey mix made from ultramarine blue, titanium white and a little of the dark mix. Apply it in a loose spiral across the painting, following the main shapes on the canvas, then use your finger to blend it into the surroundings.

Tip

If any of the brushstrokes you make appear too dark, blend the paint away with your finger. If it remains too dark, rub it away gently with a clean cloth.

17 Mix burnt sienna with cadmium orange and add a little cadmium red medium. Dilute the mix a little and blend touches in to warm the lower parts and upper right of the picture.

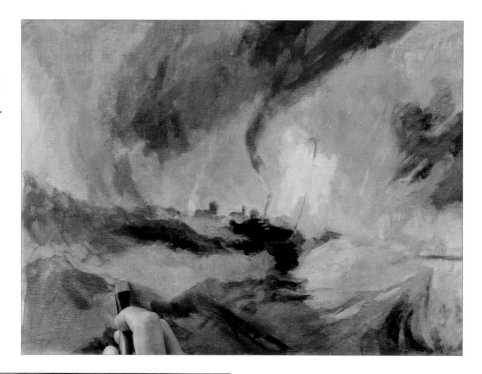

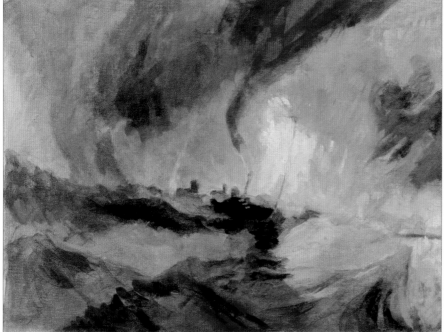

18 Dilute a mix of Hooker's green and ultramarine blue to a watery consistency with retarding medium and glaze the sea at the bottom, applying the work with a size 10 filbert. Switch to a size 1 round and apply touches of pure titanium white in the centre to suggest the paddlewheel of the steamer.

Tip

Work fairly slowly; these stages aim to build your work up gradually and require constant adjustment.

19 Continue building up the centre, upper right and the small blue area on the lower right with tiny strokes of titanium white and the size 1 round. Soften the strokes into the surroundings with your finger.

20 Switch to the size 10 filbert. Make a very dilute dark mix (ultramarine blue, permanent alizarin crimson and Hooker's green) and build up the painting with small, subtle glazed areas in the sky and sea. Contrast these changes with a very subtle few strokes of dilute titanium white in the centre.

21 Swap to the size 2 flat, and starting with the shapes in the centre and the smoke column, soften hard edges with extremely light touches of pure titanium white. Draw the brush very lightly; aim only to pick up the impression of the canvas surface. Use the blade of the brush to suggest subtle crests of foam on the water, and the flat of the brush to develop the misty feel in the sky.

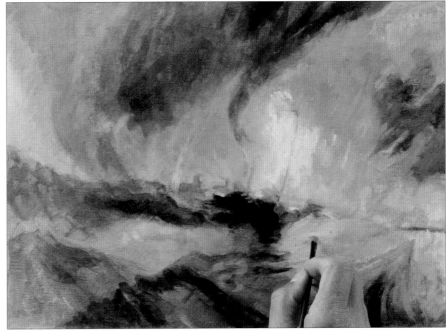

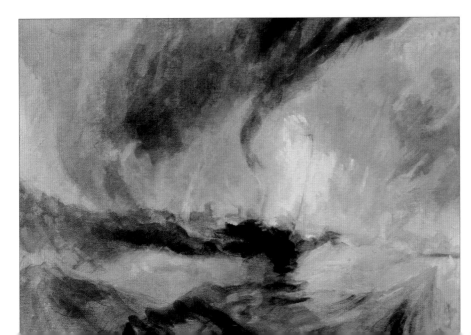

22 Make any final adjustments that you feel necessary using the colours on your palette. Adjust very slightly and gradually; and feel free to remove any last glazes with a clean cloth if you change your mind.

Overleaf

The finished painting.

Stonehenge

This watercolour, which measures 28 x 59cm (11 x 23¼in) and now hangs in the Victoria and Albert Museum, London, shows just how great Turner was at getting light in his pictures. Although small, its impact is immediate because of the use of colour and tone and I have included it because of these reasons.

TRACING 4

The original has larger sheep in the foreground but I have chosen not to include them because of the difficulty in reproducing them in any detail. It is the colours and dramatic sky that I felt should concern our reinterpretation this time.

You will need

Canvas board 56 x 38cm (22 x 15in)

Colours: transparent yellow, titanium white, ultramarine blue, Hooker's green, alizarin crimson, dioxazine purple, yellow ochre, cadmium red medium, cadmium orange

Brushes: 7/8 mop, size 10 filbert, size 2 flat, size 1 round

Masking tape and board

1 Transfer the image to canvas board, following the instructions on page 11.

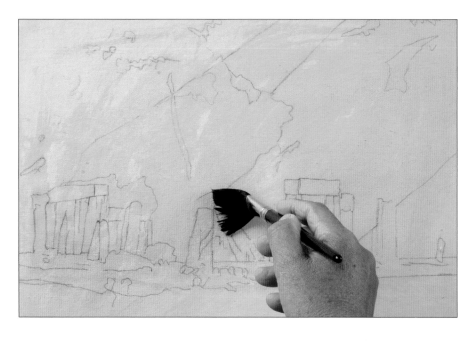

2 Apply a dilute transparent yellow wash over the whole surface using the 7/8 mop to remove the white of the canvas.

3 Switch to the size 2 flat and use fairly thick titanium white to map in the light areas of the stones and sunbeam.

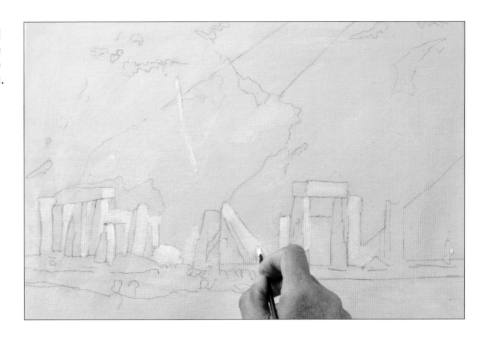

4 Make a dark mix of ultramarine blue, Hooker's green and alizarin crimson, dilute heavily, and apply with the size 10 filbert to block in the shading of the stones and to tone down the grass and sky area.

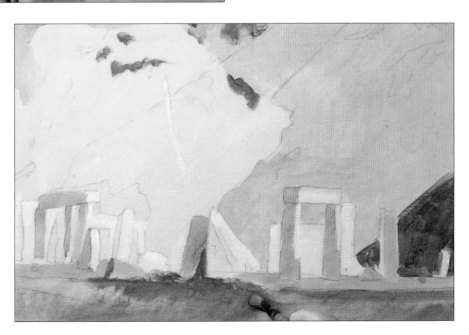

5 Starting on the lower right part of the horizon, use a mix of titanium white, dioxazine purple and ultramarine blue to tone in the sky. Use a lightly loaded size 10 filbert to tone the grass with a scrubbing motion.

6 Use a lighter-toned mix of ultramarine blue and titanium white to develop the sky a little further. Apply the mix lightly to the mid-areas of the stones, too.

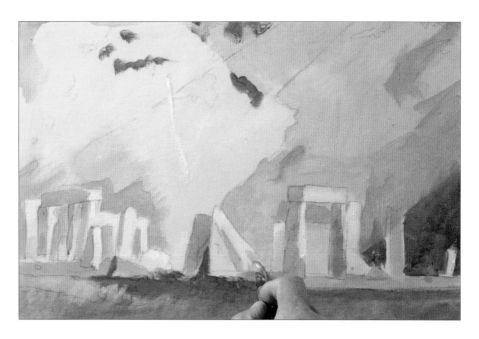

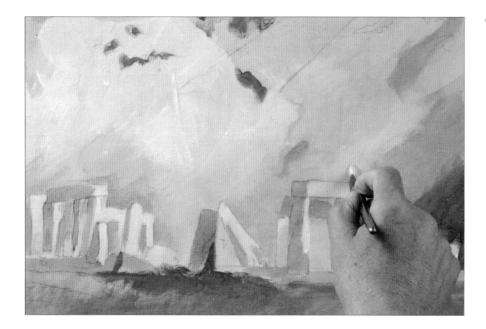

7 Still using the size 10 filbert, add a large amount of titanium white to the mix to thicken and tint it, then build up the lighter areas in the sky.

8 Begin to warm the painting by glazing yellow ochre over the sky at the top left and right. Add a little cadmium red medium to the glaze and warm the grass in the same way.

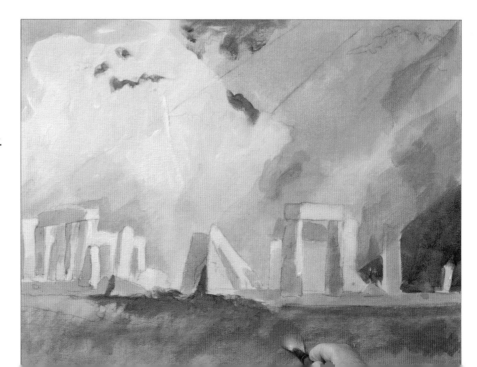

9 Switch to the size 2 flat and introduce dark tones near the horizon with horizontal strokes and a mix of dioxazine purple and alizarin crimson.

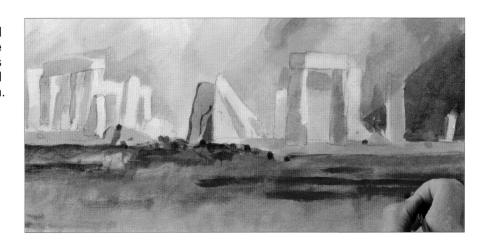

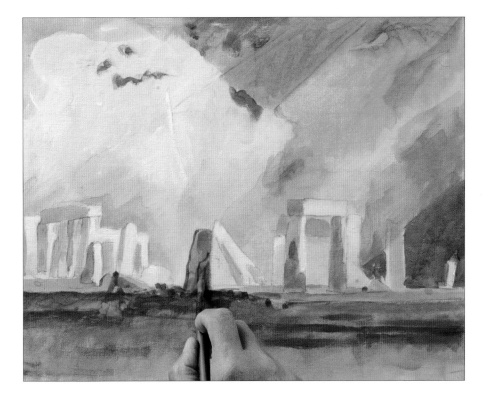

10 Add transparent yellow, yellow ochre and Hooker's green to the mix. Dilute to a glaze and add this warm orangey-green mix to the top centre and middle right of the sky. Echo the sunlight in the shade of the stones by glazing here, too.

11 Use titanium white with the size 2 flat to reinstate the highlights on the stones

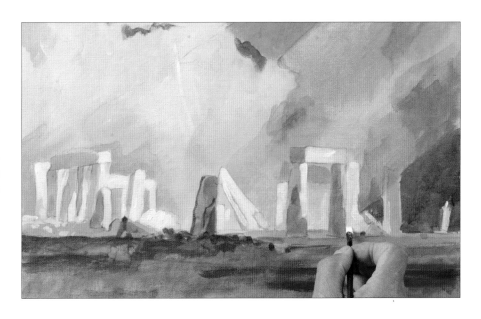

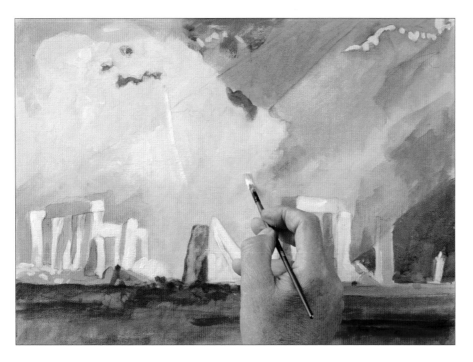

12 Scumble over the sky and central stone with titanium white to create texture and build up the light. Mix transparent yellow with plenty of titanium white and suggest the linings of the clouds. Add a tiny touch of cadmium orange to the mix and continue scumbling over the sky.

Tip

Scumbling is using fairly dry paint to overlay previous colours. It is a little like glazing, but the dry texture of the paint creates a broken effect that lets some of the previous layer show through.

13 Combine titanium white with dioxazine purple and, still using the size 2 flat, apply it fairly thickly to the sky to develop and texture it. Vary the proportions of the mix as you work.

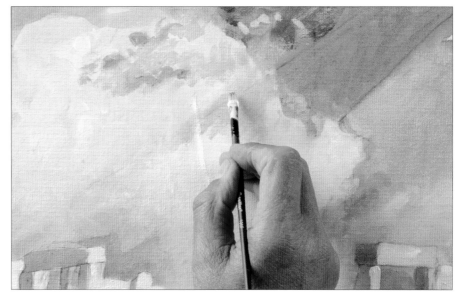

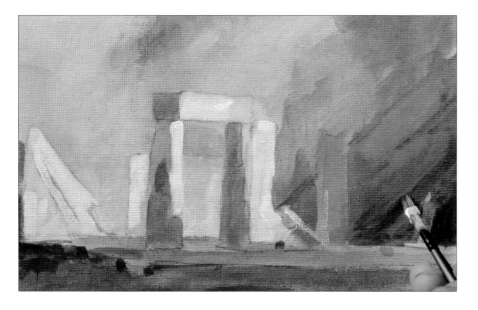

14 Add ultramarine blue to the mix and develop the sky just above the horizon on the lower right. Vary the proportions of the mix, and use diagonal brushstrokes from top right to the horizon.

15 Add Hooker's green to the mix to create a neutral grey, and switch to the size 1 round to cut details in to the stones.

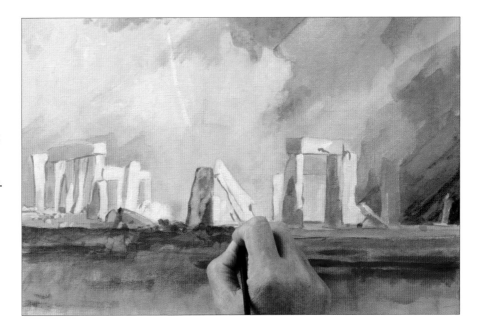

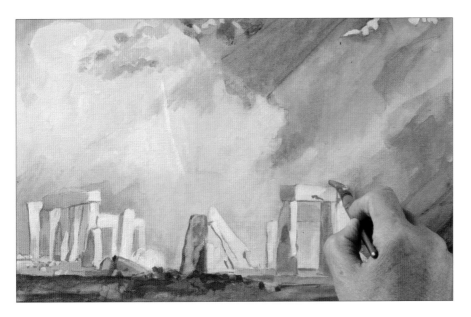

16 Glaze the sky from the top down to the horizon with very dilute Hooker's green, avoiding the centre and lightest parts of the stones.

17 Make a dark mix of ultramarine blue, permanent alizarin crimson, dioxazine purple and Hooker's green, and dot in the distant silhouettes of sheep with the size 1. Dilute the mix and glaze the area using the size 10 flat.

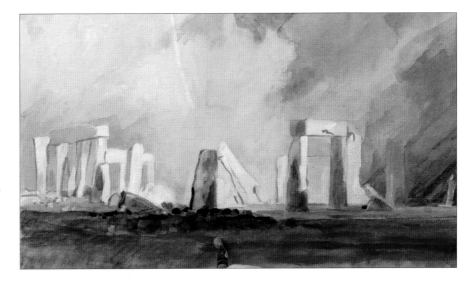

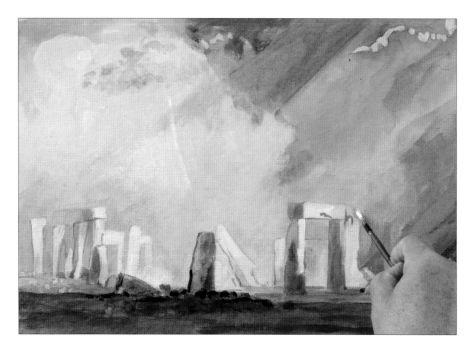

18 Add a touch of Hooker's green to titanium white and use the size 2 flat to develop the centre of the painting with a fairly thick mix. Knock back the stark lines on the stones by using the mix to scumble over them, then continue scumbling over the sky.

19 Add a touch of cadmium orange to the mix and scumble the sky, using the tips of your fingers to remove brushstrokes. This stage knocks back any hard lines and softens the painting. Vary the mix with transparent yellow.

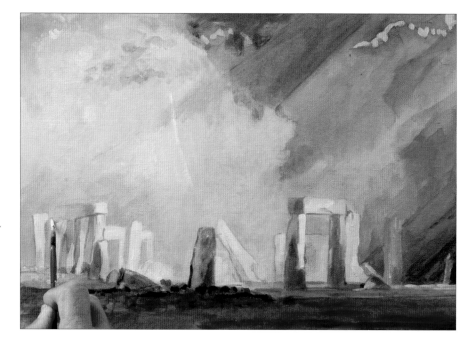

20 Continue using this mix and scumbling technique to develop the sky and knock back any hard lines.

21 Create a very pale mix of titanium white, Hooker's green, cadmium red medium and cadmium orange and scumble the darker area of the sky at the very top. Tint the mix by adding more titanium white and use this at the edges to suggest a beam of sunlight.

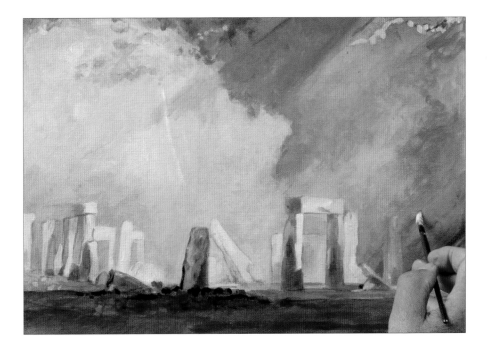

22 Continue scumbling the sky with the pale mix and the size 2 flat, varying the hue by altering the proportions of the paints used. Add a little ultramarine blue for the sky on the horizon at the right.

23 Make a fairly thick mix of titanium white with a touch of Hooker's green, then use the size 1 round to add highlights and soften hard lines on the stones.

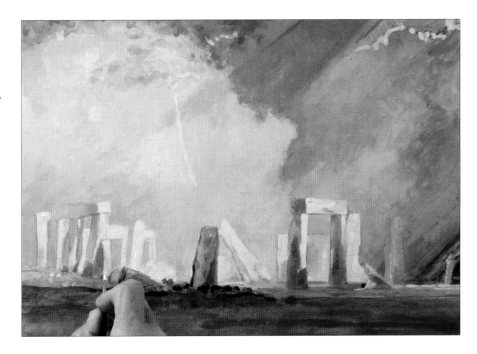

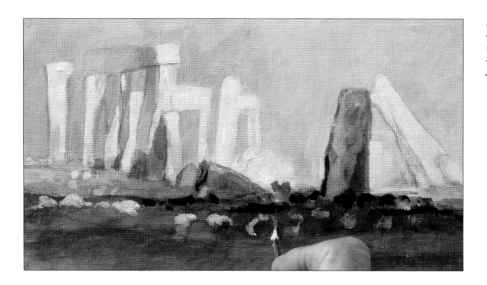

24 Suggest sheep in the midground with small strokes of titanium white applied with the size 1 round.

25 Mix dioxazine purple with titanium white and a touch of alizarin crimson, and overlay the white shapes. While still wet, add a great deal of titanium white and overlay the sheep again. Add shadows, heads and limbs with brief strokes of a dark mix made from dioxazine purple, ultramarine blue and Hooker's green.

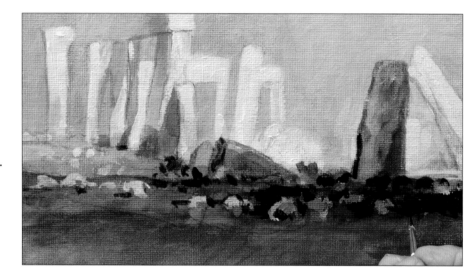

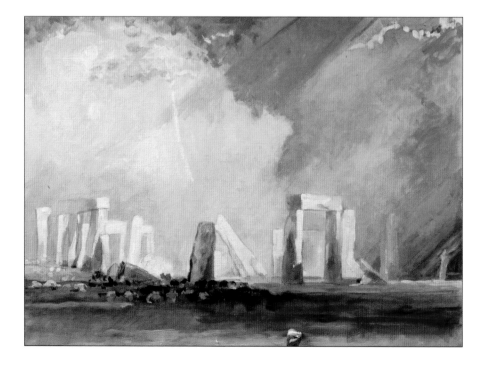

26 Break up the foreground with various mixes of titanium white and cadmium orange, applying the paint sparingly with an almost dry size 10 filbert brush.

27 Scumble a peachy version of the mix on to the sky between the sunbeam and the blue area. Make a mix of titanium white with a little Hooker's green and touches of transparent yellow and ultramarine blue. Use this to add touches across the stones, and a few touches in the sky.

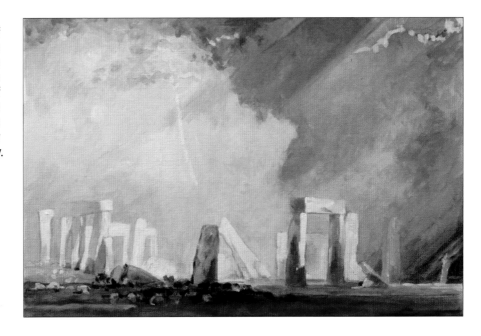

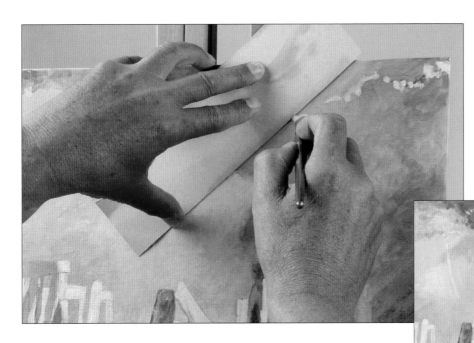

28 Make a very light mix of titanium white, transparent yellow and a tiny touch of Hooker's green. Make sure the painting is completely dry, then lay a straight edge over the edges of the sunbeam and gently draw an almost dry size 10 filbert back and forth down the edges. Repeat over the other sunbeams (see inset).

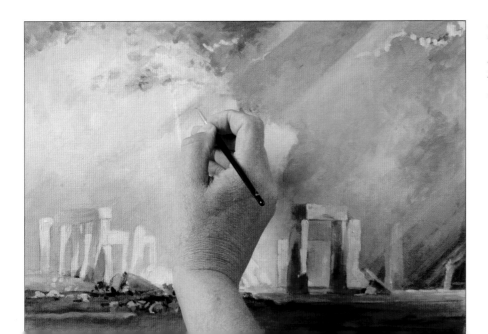

29 Using the mixes on your palette make any final tweaks you feel necessary, adding some final notes of titanium white and dioxazine purple in the sky.

Overleaf

The finished painting.

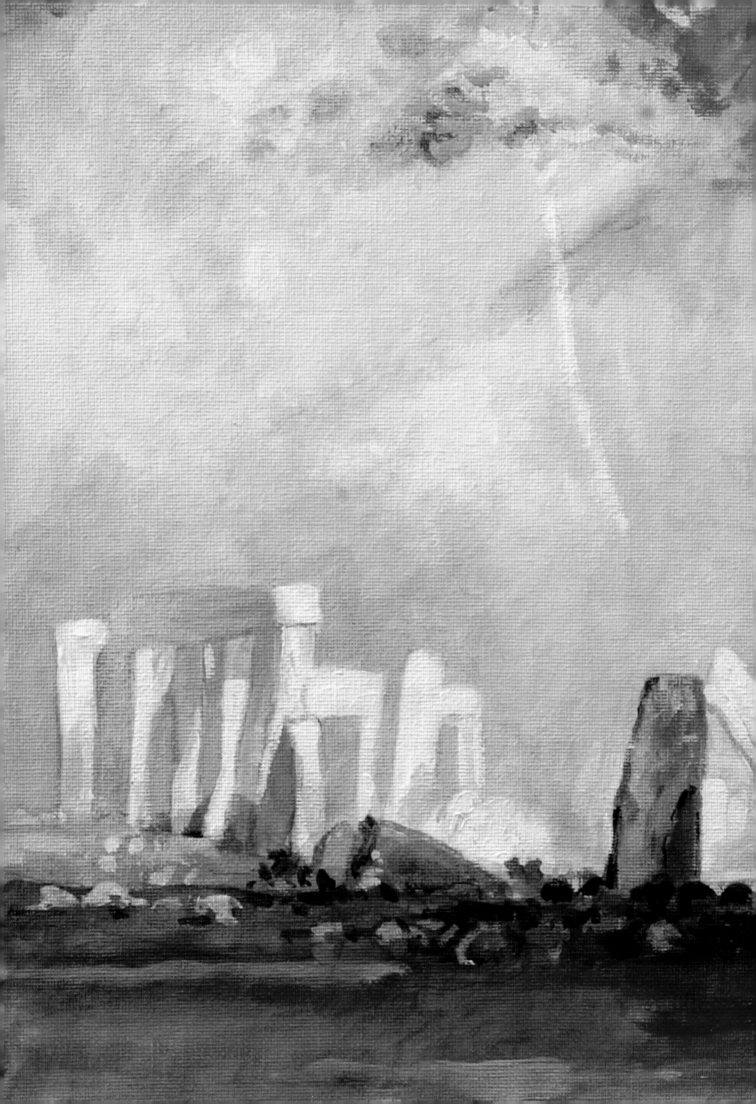

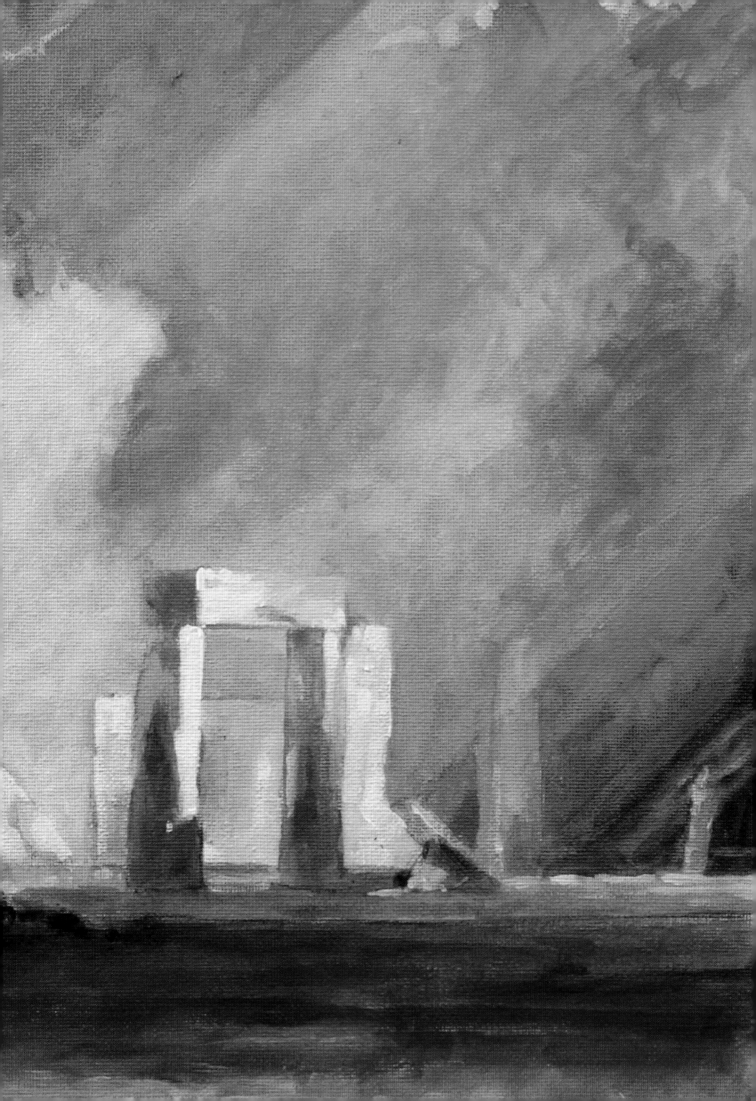

Peace – Burial at Sea

This image, of Turner's friend Sir David Wilkie, who died suddenly whilst in Gibraltar, being lowered into the sea, is a masterstroke of design and colour. The dark, almost funereal, silhouetted shapes of the boats contrast so well with the hot colours of the burning torches in between.

TRACING **5**

Few artists have had the ability to convey such a sense of mourning and solemnity to give us such an iconic image, which I hope you will enjoy painting.

The original may be viewed in the Tate Gallery in London. It measures approximately 86 x 86cm (34 x 34in), and shows just how good Turner was in representing tone in his paintings.

You will need

Canvas board 56 x 38cm (22 x 15in)

Colours: alizarin crimson, titanium white, burnt umber, ultramarine blue, dioxazine purple, cadmium orange, transparent yellow, Hooker's green, permanent alizarin crimson, cadmium red medium, burnt sienna, yellow ochre

Brushes: 7/8 mop, size 10 filbert, size 2 flat, size 1 round

Masking tape and board

1 Transfer the image to canvas board, following the instructions on page 11.

2 Make a very dilute mix of permanent alizarin crimson and use a 7/8 mop brush to stain the canvas.

3 Swap to the size 10 filbert. Wait until the crimson wash is dry, then use fairly thick titanium white to block in the light-toned areas.

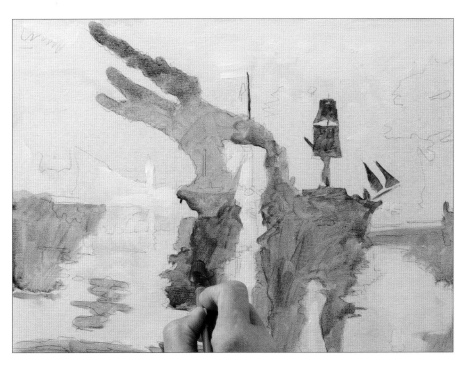

4 Switch to the size 2 flat and add small amounts of ultramarine blue and dioxazine purple to burnt umber. Block in the dark-toned areas, varying the proportions of the mix to create variety.

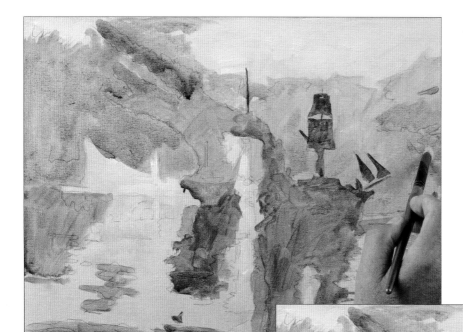

5 Make a dilute mix of ultramarine blue and dioxazine purple, and wash it in on the sky as shown, instating the mid-tones. Drop in more ultramarine blue on the left and touches on the right for a natural variation.

6 Switch to the size 2 flat and make a mix of cadmium orange, transparent yellow and titanium white. Apply the mix fairly strongly to the torches and reflections in the centre of the sea and less strongly in small areas on the left and right as shown. Finally, add some subtle touches to the smoke in the centre.

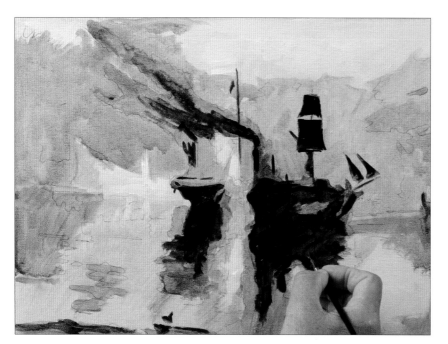

7 Mix Hooker's green, ultramarine blue, burnt sienna and dioxazine purple for a strong dark. Use this mix with the size 2 flat to strengthen the dark-toned areas, switching to the size 1 round for details.

8 Add a little dioxazine purple to permanent alizarin crimson and dilute heavily. Use this dilute mix with the size 10 filbert to paint the sky behind the ship on the right, and to add touches to the sea and sky.

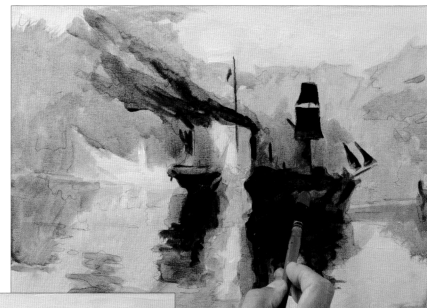

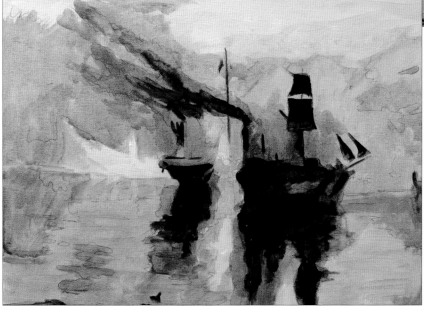

9 Mix Hooker's green and yellow ochre and dilute heavily. Use horizontal brushstrokes to wash over the sea. Add touches as shading to the large cloud on the top right and to the smoke in the centre.

10 Allow the painting to dry completely, then add touches of permanent alizarin crimson and ultramarine blue to dioxazine purple and dilute heavily. Still using the size 10 filbert, glaze the sky and dark areas with this wash. Allow the glaze to dry, and repeat if necessary until you achieve the tone shown here.

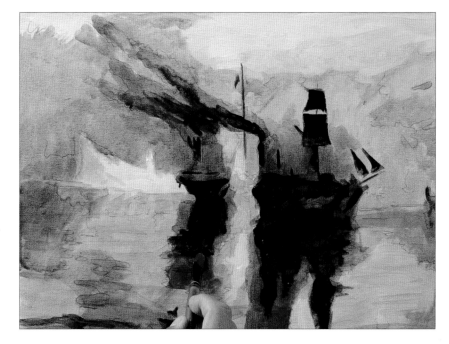

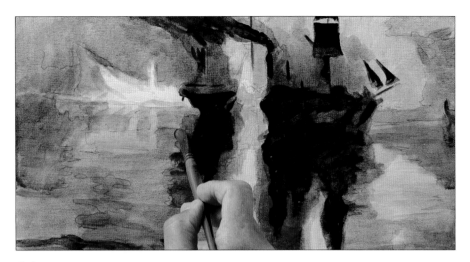

11 Add Hooker's green to the mix and dilute again. Use this new mix to tone down the sea and sky with a glaze. Apply the glaze with horizontal strokes to give a peaceful impression to the sea.

12 Strengthen the torches and their reflection with pure cadmium orange, applied strongly in the warm areas with the size 1 round.

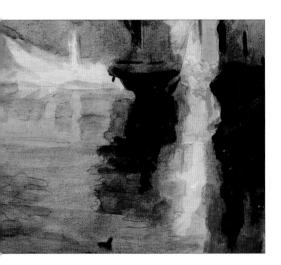

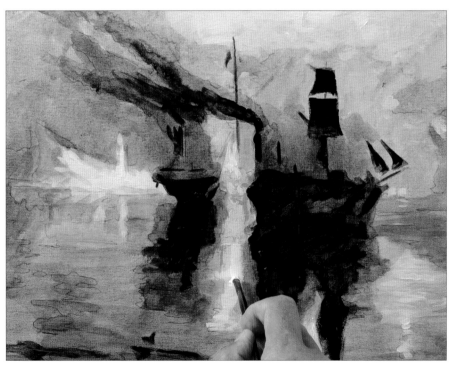

13 Add a little cadmium orange to transparent yellow and develop the reflection and hot area with thick strokes. Use more subtle brushstrokes to warm the horizon on the left with the same mix.

14 Use pure titanium white with the size 2 flat to lift out highlight areas that have been covered over. Again, keep using horizontal strokes on the sea, and looser strokes over the rest of the painting.

15 Mix Hooker's green, burnt umber and titanium white, and use it fairly thickly with horizontal strokes to break up and build up the shapes on the sea. Use a few touches in the sky.

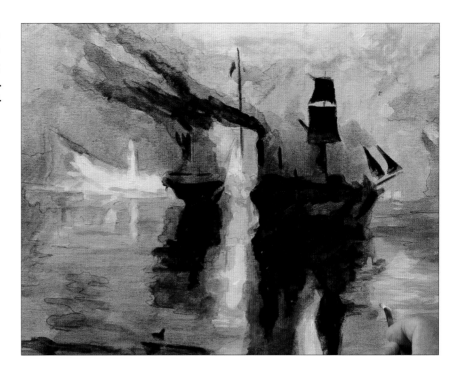

16 Mix titanium white, ultramarine blue and dioxazine purple and use the size 2 flat to develop the sky on the top left. Use short, random strokes to apply the paint fairly thickly, create texture and cover the lines on the sky. Vary the amount of titanium white in the mix to vary the hue across the sky.

17 Make a dark mix of burnt umber, yellow ochre and ultramarine blue and use the size 10 filbert to strengthen the dark areas. Apply the paint fairly thickly on the hulls of the ships, and feather it on lightly to represent the smoke and reflections in the foreground.

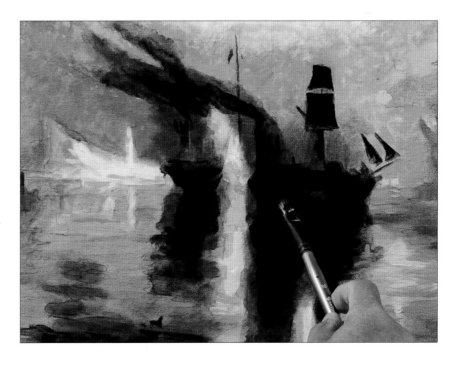

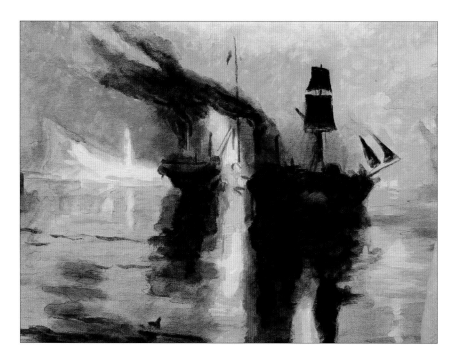

18 Use the same mix with the size 1 round to add rigging, masts and other fine detail to the silhouetted ships. Dilute the mix a little and add fine touches on the water on the lower left and the horizon on the right.

19 Add a little cadmium red medium and cadmium orange to the mix and use the size 1 round to vary the darks, add details to the ships and the edges of the reflections. Dilute the mix a great deal, and use this to knock back very strong areas in the sea, blending it away with your finger.

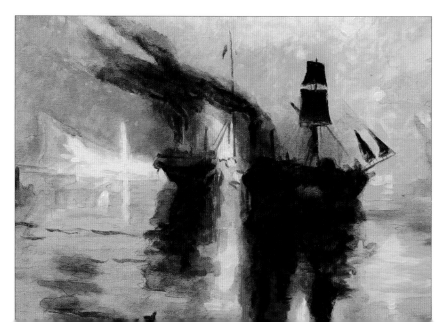

20 Use pure titanium white with the size 2 flat to build up and develop highlights and texture on the clouds, light areas on the horizon and in the foreground. Add a touch of ultramarine blue to the mix and build up the sky.

21 Create a neutral mix from titanium white with small amounts of ultramarine blue, Hooker's green and cadmium orange. Vary the amounts and use the size 2 flat to develop the various areas of the sea. Similarly, begin to build up the darks with the dark mix (alizarin crimson with ultramarine blue and dioxazine purple).

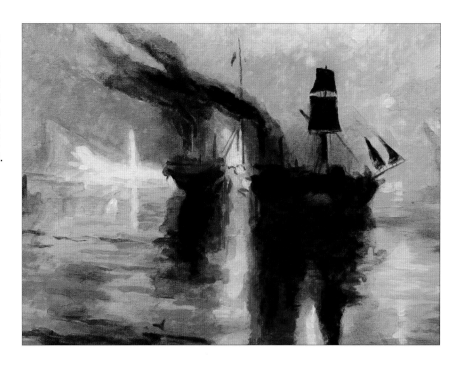

Tip

At this scale, and using acrylics, the best way to represent Turner's beautiful sea is to abstract it slightly and build it up gradually with varied initial washes and multiple touches of different mixes.

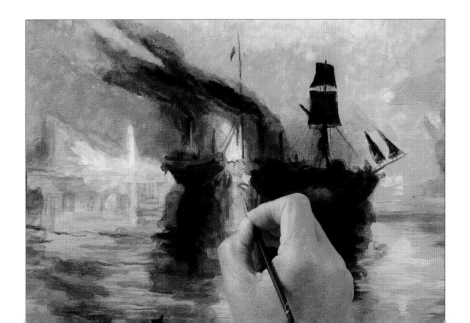

22 Continue building up the dark areas with the same mix, and touch in the bird and its shadow in the centre foreground. Mix ultramarine blue, burnt sienna and dioxazine purple, dilute, and use the new mix to glaze the smoke and reflections. Use the blade of the brush to touch in some details on the water's surface, including vertical lines on the left, below the white area.

23 Adjust the tones on the water with pure titanium white applied with the size 2 flat. Add touches of transparent yellow and Hooker's green to the mix to vary the tone. Use very light, horizontal, brushstrokes so that the paint just barely brushes the surface. Use the mixes on your palette to make any final adjustments with the size 1 round to finish.

Overleaf

The finished painting.

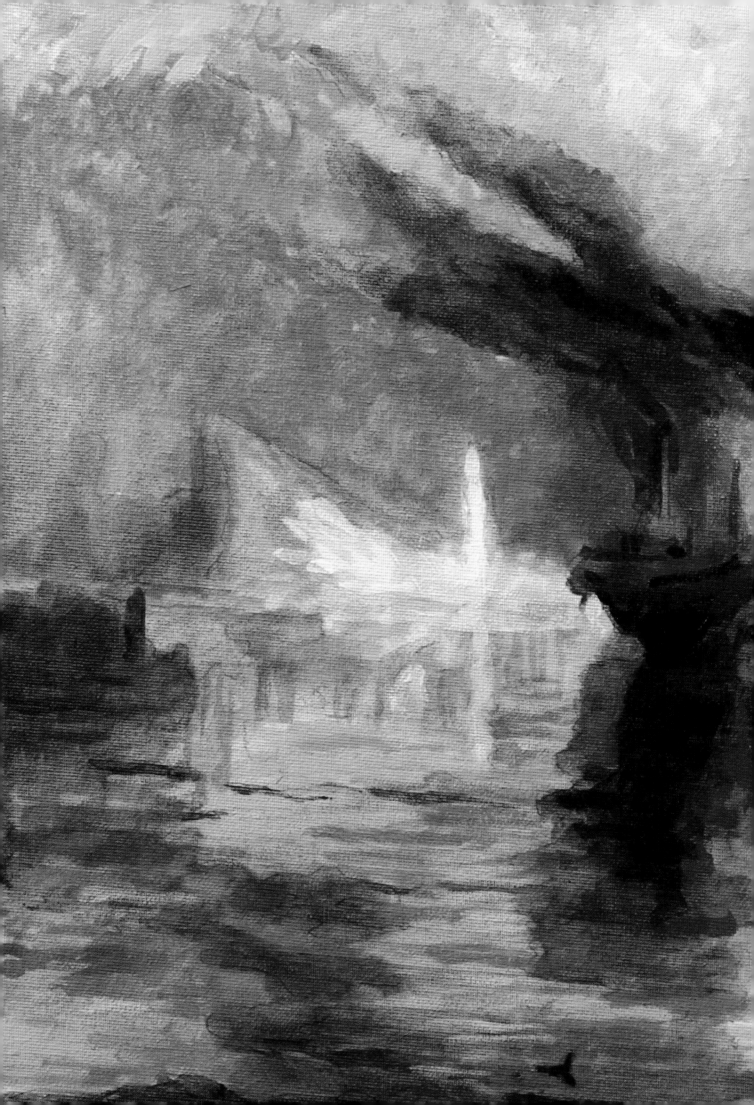

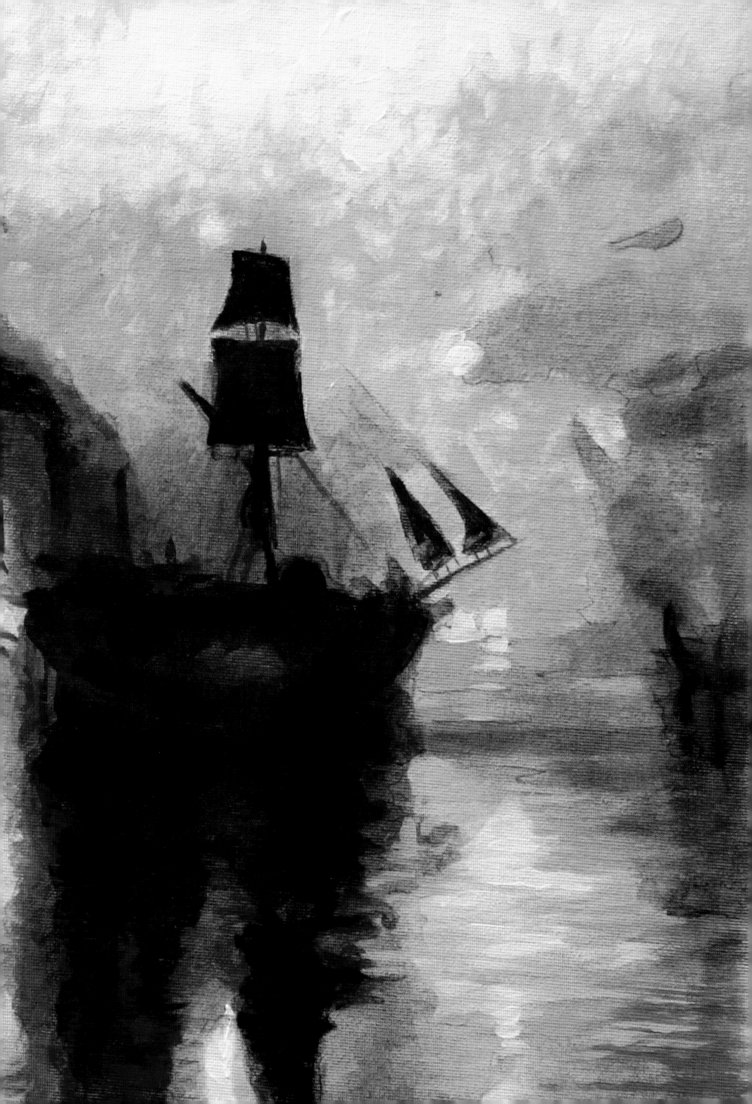

Valley of the Washburne

Valley of the Washburne

I chose this painting partly because so many of Turner's famous images are seascapes and I wanted a contrasting composition for this book to demonstrate the master's versatility, and partly because of my own interest in landscape painting.

The original is part of a series of around forty watercolours, completed around 1815–1824, at or near Farnley Hall, the home of Walter Fawkes, Turner's patron. Although small, the tonal effect is extremely good and the original contains body colour (white added to pigment) enabling me to get nearest to his original painting technique while using acrylics.

TRACING

6

You will need

Canvas board 56 x 38cm (22 x 15in)

Colours: yellow ochre, ultramarine blue, Hooker's green, permanent alizarin crimson, titanium white, transparent yellow, cadmium red medium, dioxazine purple, burnt umber

Brushes: 7/8 mop, size 10 filbert, size 2 flat, size 1 round

Masking tape and board

1 Transfer the image to canvas board, following the instructions on page 11.

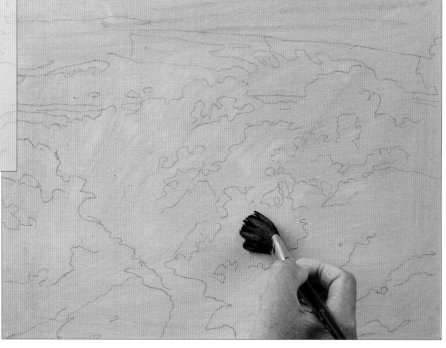

2 Cover the board with a dilute wash of yellow ochre, applying it with the 7/8 mop brush.

3 Allow the wash to dry thoroughly, then mix ultramarine blue with a little Hooker's green and use the size 10 filbert to apply it over the background and the foliage in the midground.

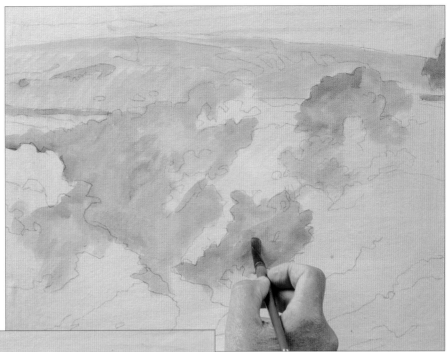

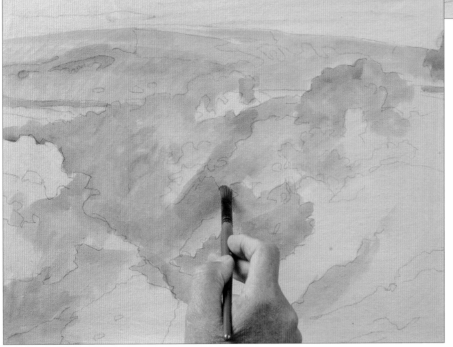

4 Wash in dilute permanent alizarin crimson with the size 10 filbert over the clearing in the centre and the foreground.

5 Apply a second layer of yellow ochre over the areas shown to reinforce them.

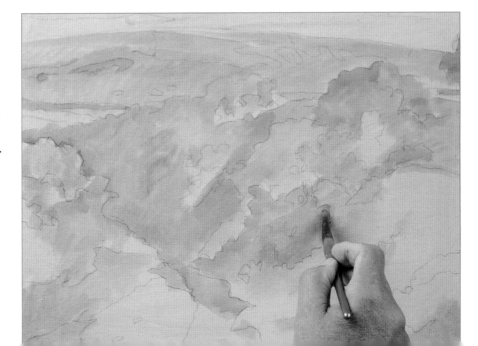

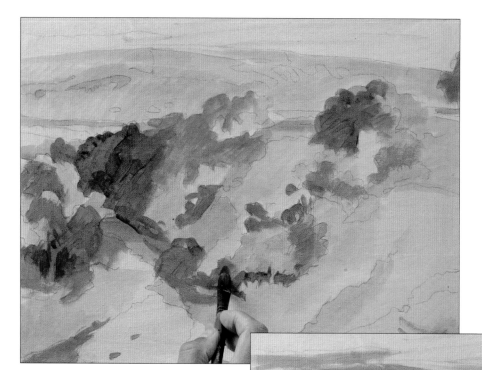

6 Still using the size 10 filbert, begin to apply darks with a mix of permanent alizarin crimson and Hooker's green.

7 Drop in the river using a fairly thick mix of ultramarine blue and titanium white. Use the same mix in the sky at the top left, then dilute the mix a little and draw the brush over the background hills.

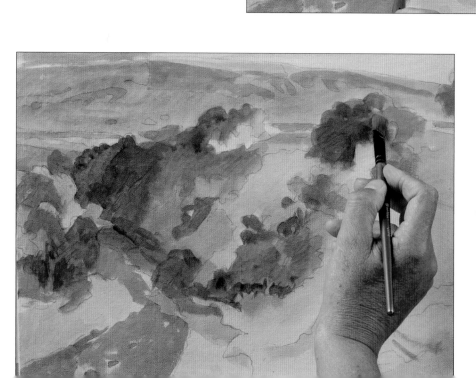

8 Mix ultramarine blue, transparent yellow and Hooker's green and use this to suggest the foliage and complete the initial stages of defining the tonal areas. Dilute the mix for variety.

9 Make a rich brown by mixing cadmium red medium with Hooker's green and swap to the size 2 flat. Begin to fill the right midground, using short strokes. Work forward to the foreground, using slightly longer strokes as you advance.

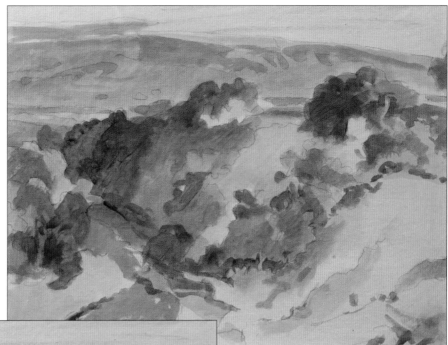

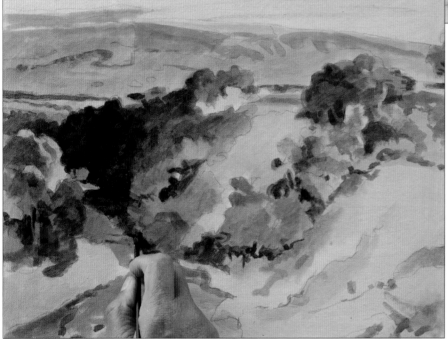

10 Still using the size 2 flat, combine Hooker's green and dioxazine purple, and drop in strong darks over the foliage area, paying particular attention to, and saving the darkest tones for, the valley area.

11 Use the size 2 flat to apply titanium white across the sky and on the lower right foreground. Use the blade of the brush to touch in short strokes of white to suggest the town of Otley Chevin in the background, and highlights on the river and foliage.

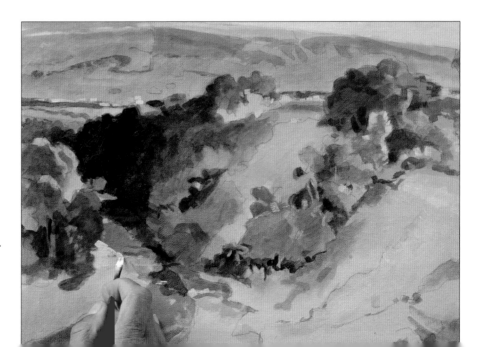

12 Dilute permanent alizarin crimson and add a touch of Hooker's green. Use a scrubbing motion with the size 10 filbert to work the watery mix over the centre clearing and the edges of the painting.

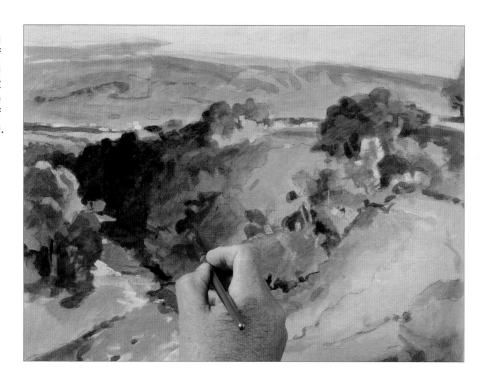

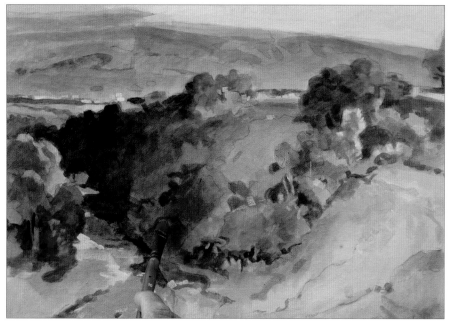

13 Glaze the upper left of the sky, the background and the midground with dilute ultramarine blue. This completes the base colour stage, so we can begin to build up texture.

14 Mix transparent yellow, Hooker's green, yellow ochre and cadmium red medium, and use the size 1 round to apply short strokes to the foliage in the midground to represent highlights. Vary the proportions of the colours and add touches of mid-toned browns across the ground and foliage areas.

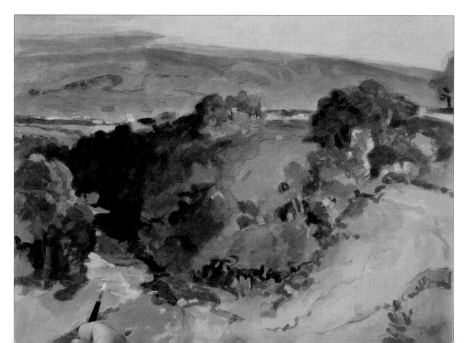

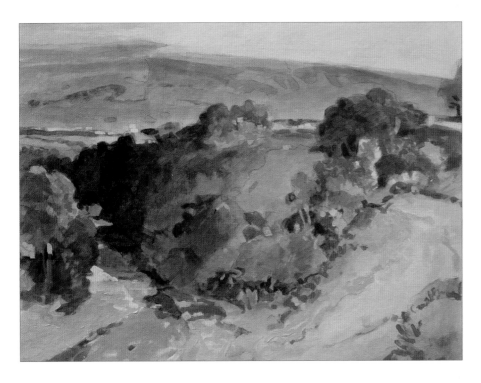

15 Add some titanium white and a tiny touch of ultramarine blue to the mix and develop the ground and foliage further. Aim to build up the texture by using fairly thick paint.

16 Create a dark mix of permanent alizarin crimson, ultramarine blue and Hooker's green and build up the shadows, using the tip of the brush to 'tickle in' small strokes. Add titanium white to the mix and develop the midtones in the shadows.

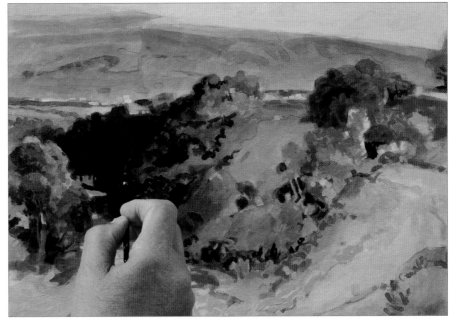

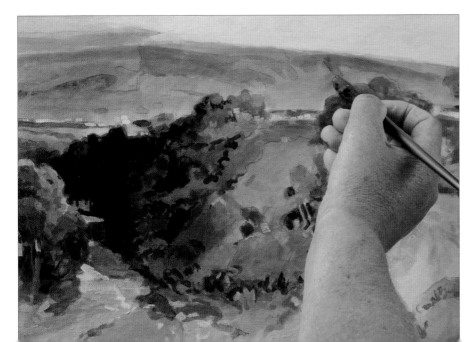

17 Make a very dilute mix of cadmium red medium and Hooker's green, and use the size 10 filbert to glaze the midground and foreground. Glaze the hills in the background with dilute ultramarine blue. These glazes link the colours in the areas together and create the impression of distance.

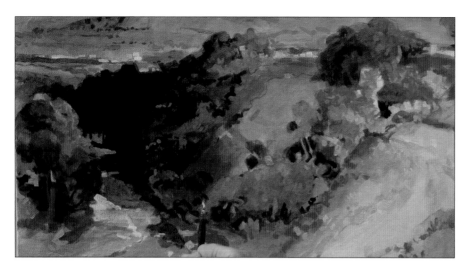

18 Use the size 2 flat to continue building up the texture and body of the paint in the foreground. Use a mix of titanium white with a little yellow ochre and a touch of cadmium red medium for the light area of open ground on the right, then add ultramarine to make a grey-green. Use the grey-green mix with the size 1 round to develop the foliage.

19 Still using the size 1 round, continue building up the texture across the painting with the mixes on your palette. Work gradually to tighten up the painting, developing the texture with short strokes. Introduce burnt umber to the mixes to create contrast, and let the brush do the work, creating broken strokes across the foliage and ground.

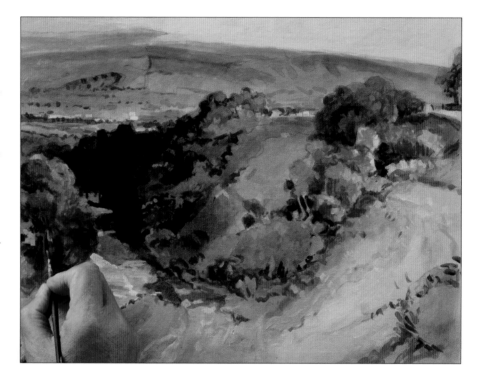

20 Use the size 10 filbert with very dilute burnt umber as a glaze to knock back the midtones on the slope from the clearing down to the river, and at the lower parts of the foliage to help give the trees shape and form.

21 Use the size 2 flat to apply pure titanium white to the sky, building it up and giving it strength. Add a little ultramarine blue and work it into the left-most parts of the sky with the size 1 round.

22 Create a mix of titanium white, transparent yellow, Hooker's green and yellow ochre. Use the size 1 round to tick in short lines, vertical and near-vertical. Add more titanium white and repeat, to create the impression of sunlight on the leaves.

23 Continue across the painting with these short strokes, building up the texture and creating interest with the various mixes on your palette. Continue until you are happy with the finish of the composition and allow to dry.

Overleaf

The finished painting.

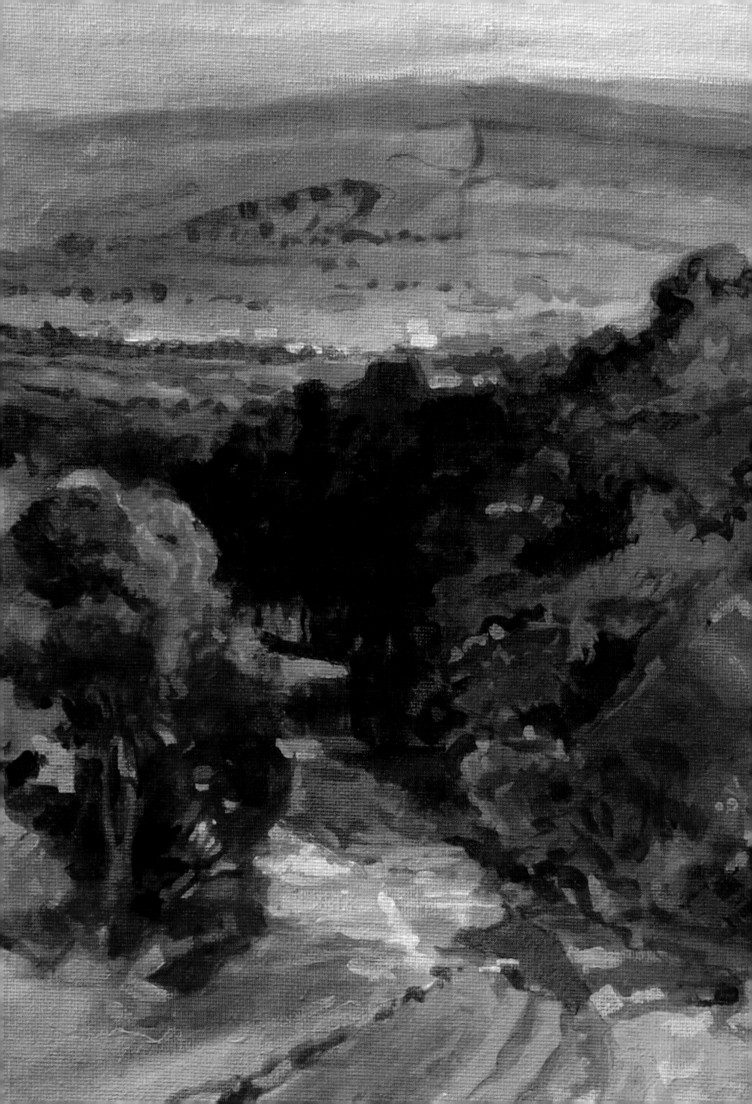

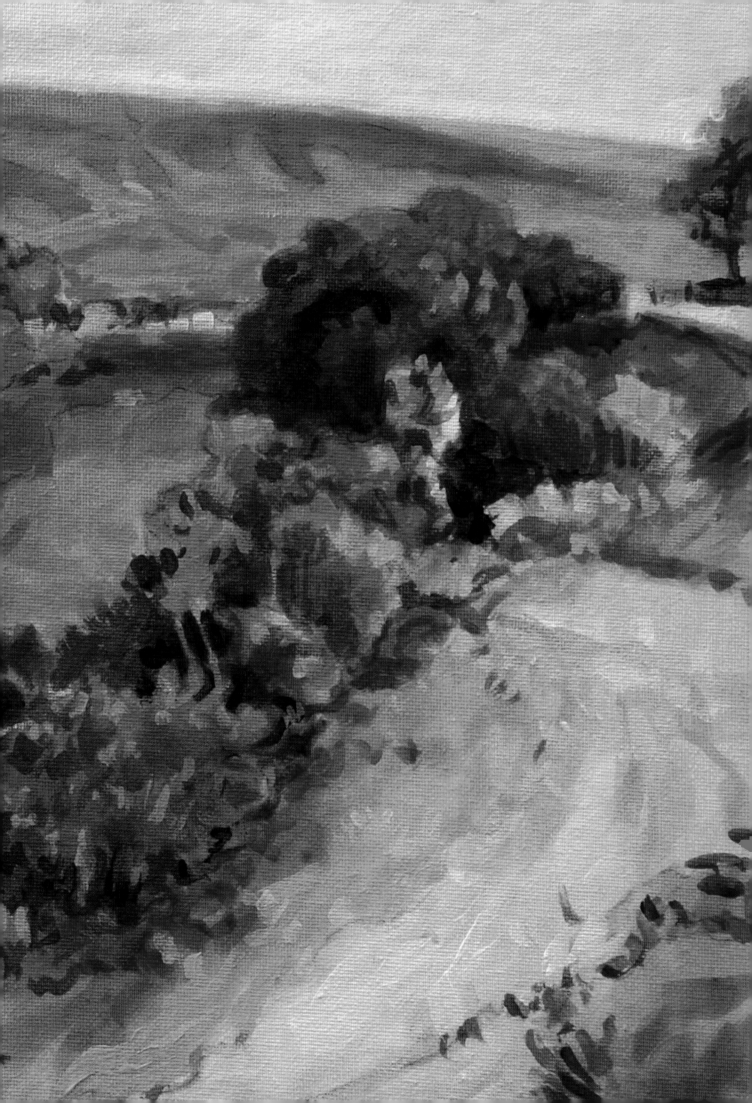

Index

Deer in a Snowstorm

101 x 76cm (40 x 30in)

When I was shown a photograph of deer in a snowy landscape, taken by an old friend, I wanted to paint it, but I felt that the original plain-toned sky would be improved with the 'Turner touch'. The sky from Hannibal and his Army Crossing the Alps, *painted in 1812 and now hanging in the Tate Gallery, was just what I felt the composition needed. The result of combining the dramatic sky with the photograph for my composition is, I feel, an image made better with the great Master's help. Thank you, Mister Turner.*

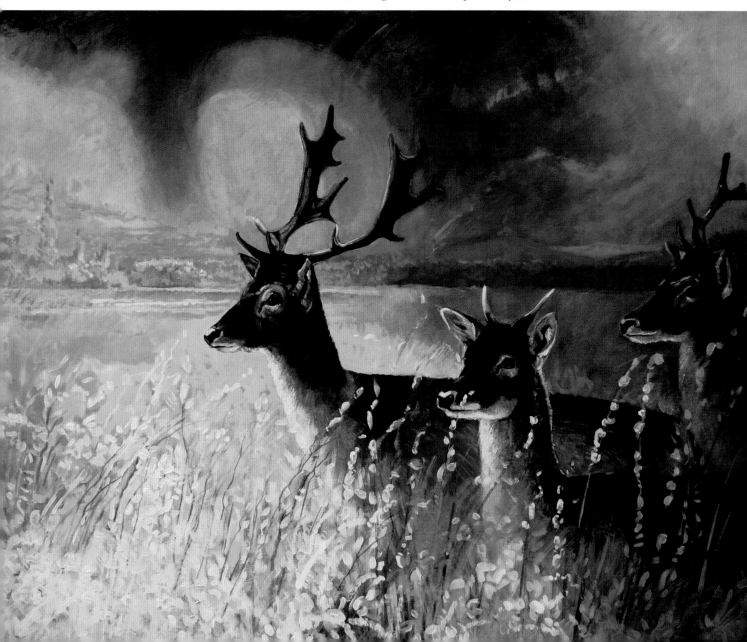